Christopher Wright

FRENCH PAINTING

MAYFLOWER BOOKS
NEW YORK

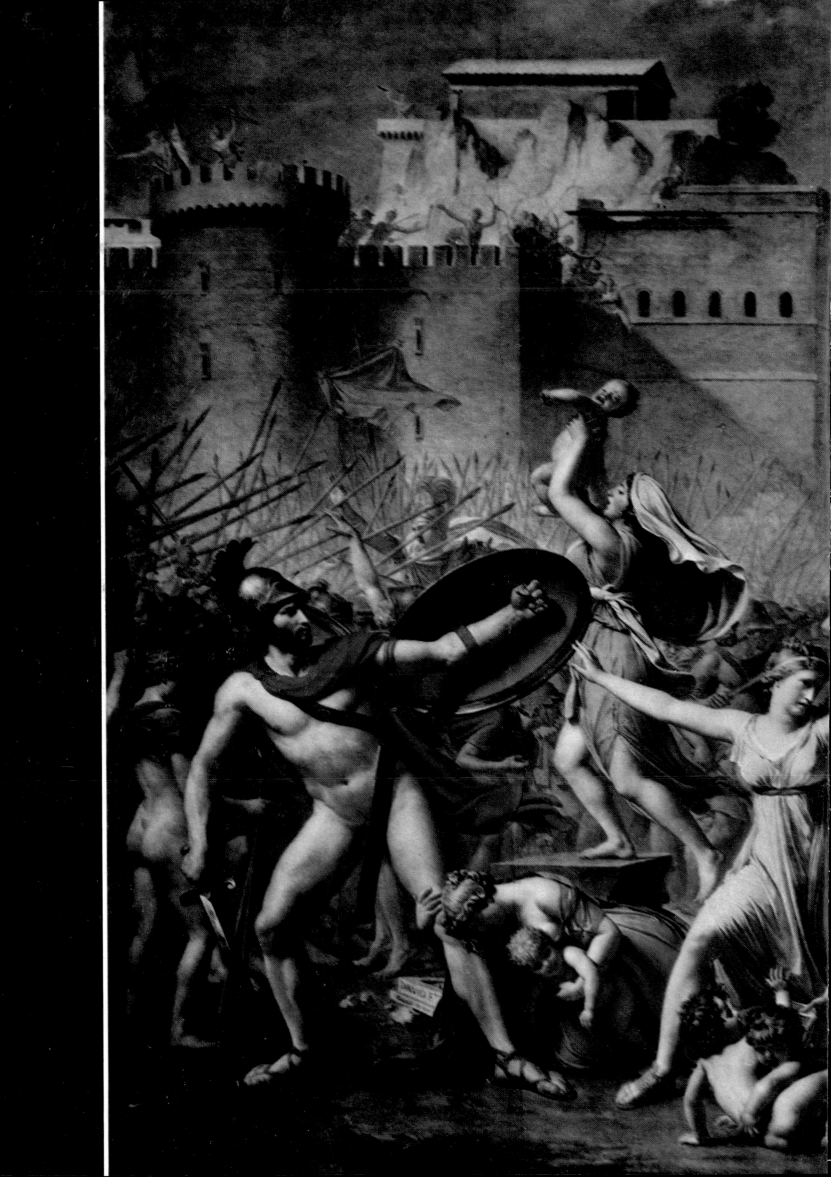

Christopher Wright

FRENCH PAINTING

For James Birkett

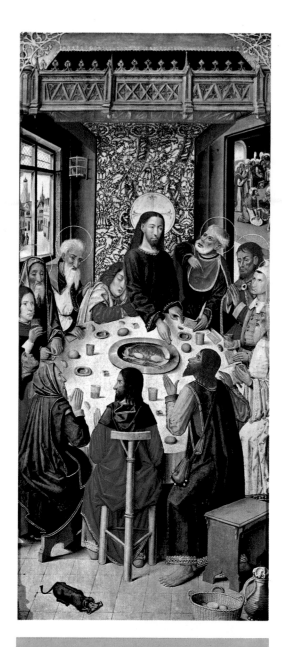

OVERLEAF **David**: *Intervention of the Sabine Women*. 386 × 520cm. 1797

MAYFLOWER BOOKS. INC.,
575 Lexington Avenue. New York City 10022.

© TEXT 1979 Phaidon Press Limited
© DESIGN 1979 Heraclio Fournier. S. A.

The film positives of the illustrations are
the property of Heraclio Fournier. S. A.

Library of Congress Cataloging in Publication Data

 WRIGHT. CHRISTOPHER. 1945–
 French painting.

 1. Painting. French. 2. Painting. Renaissance –
 France. 3. Painting. Modern – France. I. Title.
 II. Series.
 ND544.W74 759.4 78-25567
 ISBN 0–8317–3566–X
 ISBN 0–8317–3567–8 pbk.

Printed and bound in Spain by HERACLIO FOURNIER SA. *Vitoria.*
First American edition
Filmset in England by SOUTHERN POSITIVES AND NEGATIVES
(SPAN). *Lingfield. Surrey*

Master of Amiens: *Scene from the Life of Christ*, 117·2 × 50·9cm, late 15th century

The set of panels, one of which is illustrated here, came from a Carthusian monastery near Abbeville. It was probably painted in the 1480s by a painter whose name has not survived. There were several such painters active at that time in the Amiens/Abbeville region. They differed from their close northern neighbours in The Netherlands by the fact that they lacked a firm tradition. The result was that the Netherlandish motifs were adopted without real understanding, and the effect of this was to give the pictures a strident dignity, which is very personal. Most of the surviving panels are in the museums of Abbeville and Amiens.

FRENCH PAINTING AS A WHOLE from the fifteenth to the nineteenth century has few unifying elements. Some categories or general moods have caught popular or academic imagination. It has been claimed that frivolity is the keynote of the eighteenth century, and many writers believe that French art is typified by an underlying classicism, which threads its way across three centuries from Poussin to Ingres. Both these characteristics do occur in French painting. Fragonard's delicious sense of humour assures him a special place among artists who opposed ideas that art should conform to a particular set of rules. Poussin did introduce a unique sense of order, inspired by classical antiquity, into his pictures, and they became all too easy for painters, who either lacked or did not wish to use their imaginations, to imitate.

Perhaps the strongest thread in the whole of French art is its close relationship to its patrons — mostly the monarchy and the aristocracy. But if only the painters who had this type of patronage were discussed, Georges de La Tour and Chardin would be left out. France never produced a dominating genius who affected a whole generation of painters or set the style for a period of art. There was never the great flowering of painting that occurred in Italy. Instead there

Poussin: *Bacchus-Apollo*, 98 × 73·5cm, c.1626

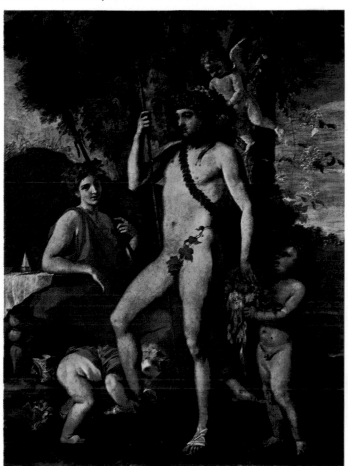

were periods of increased activity, roughly corresponding to the periods of economic and political stability of the country.

It is not often realized that there was any easel painting in France in the late Middle Ages. The reasons why the activity was restricted are hard to find. Although the fifteenth century was a period of political disturbance, France compared to the rest of Europe, had relative prosperity. In fact by the end of the fifteenth century France had begun to play an important role in Italian politics. Francis I became early in the following century the dominant European monarch, and his artistic instincts were clearly oriented towards Italy.

The second half of the sixteenth century was a time of political and religious instability, and little painting was produced at all. There was a distinct revival in the first years of the seventeenth century, culminating in the immensely active reign of Louis XIV, under whose watchful aegis all the arts were set on an official footing.

In the eighteenth century the monarchy and its satellite aristocracy dominated the arts. This was a direct legacy of Louis XIV. But in the last years of the *ancien régime*, just before 1789, some painters had achieved a considerable amount of stylistic independence, and were able to produce pictures quite out of keeping with the tastes of the court.

Considering the enormous political and social changes that took place during the short-lived Revolution and the Napoleonic period, there was a remarkable stylistic unity. This can be attributed to the immensely powerful figure of Jacques-Louis David and his extraordinary ability to teach his style to quite literally hundreds of pupils.

Much has been written by French critics on the period covered by this book concerning the national character of French art. Significantly, many French painters before about

Pages 6–7, 8, 9 **Master of Avignon Pietà:** *The Avignon Pietà*, 162 × 218cm, and details, 1450s

Although the authorship of this picture, originating from Villeneuve-lès-Avignon, is still disputed, its quality as a work of art has never been in doubt. Its style is quite isolated since no comparable picture survives. In recent years it has been attributed to the painter Enguerrand Quarton (or Charenton), who is known to have been active in the Avignon area in the middle years of the fifteenth century. The picture's real achievement lies in the depiction of the mood of pathos by exaggerating the forms. It is not often realized that this type of expression is quite rare in the fifteenth century, for so many painters were striving either towards their own brand of realism, as is the case with Jan van Eyck and his Netherlandish followers, or towards a perfection of balance, as in the work of Piero della Francesca.

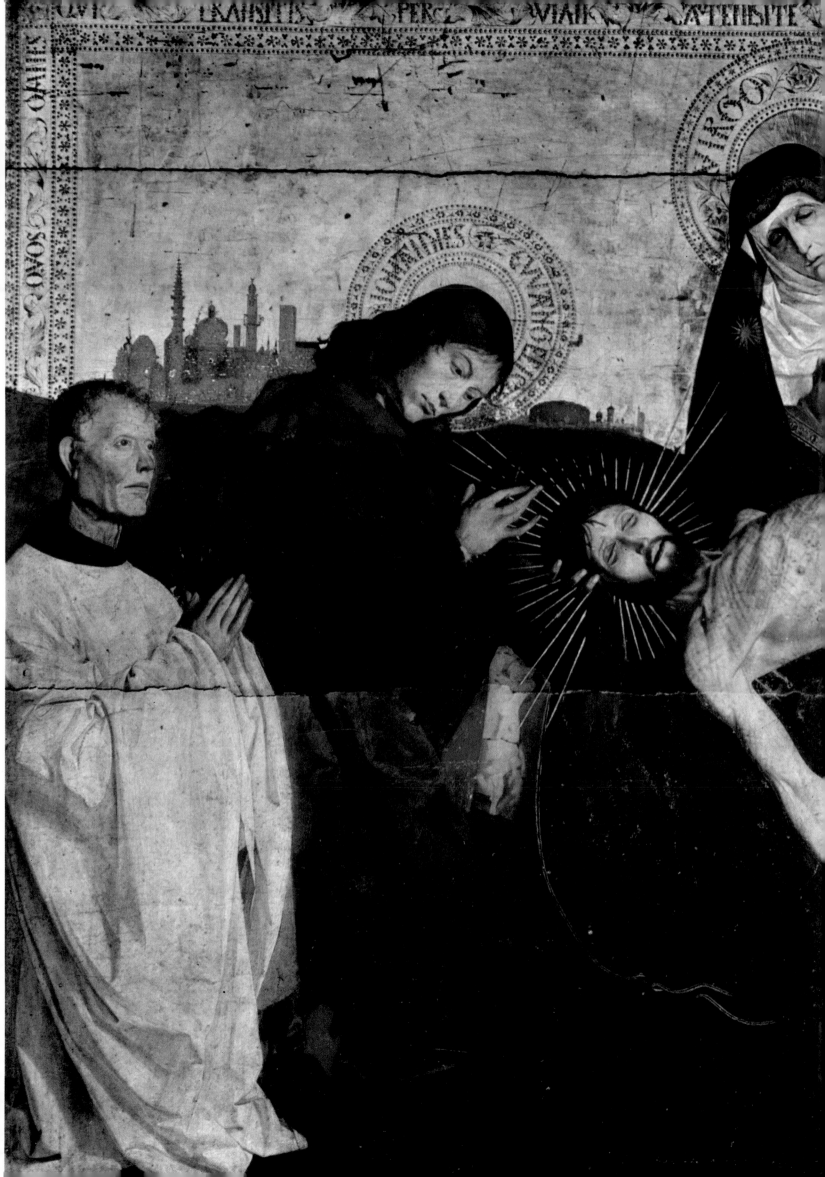

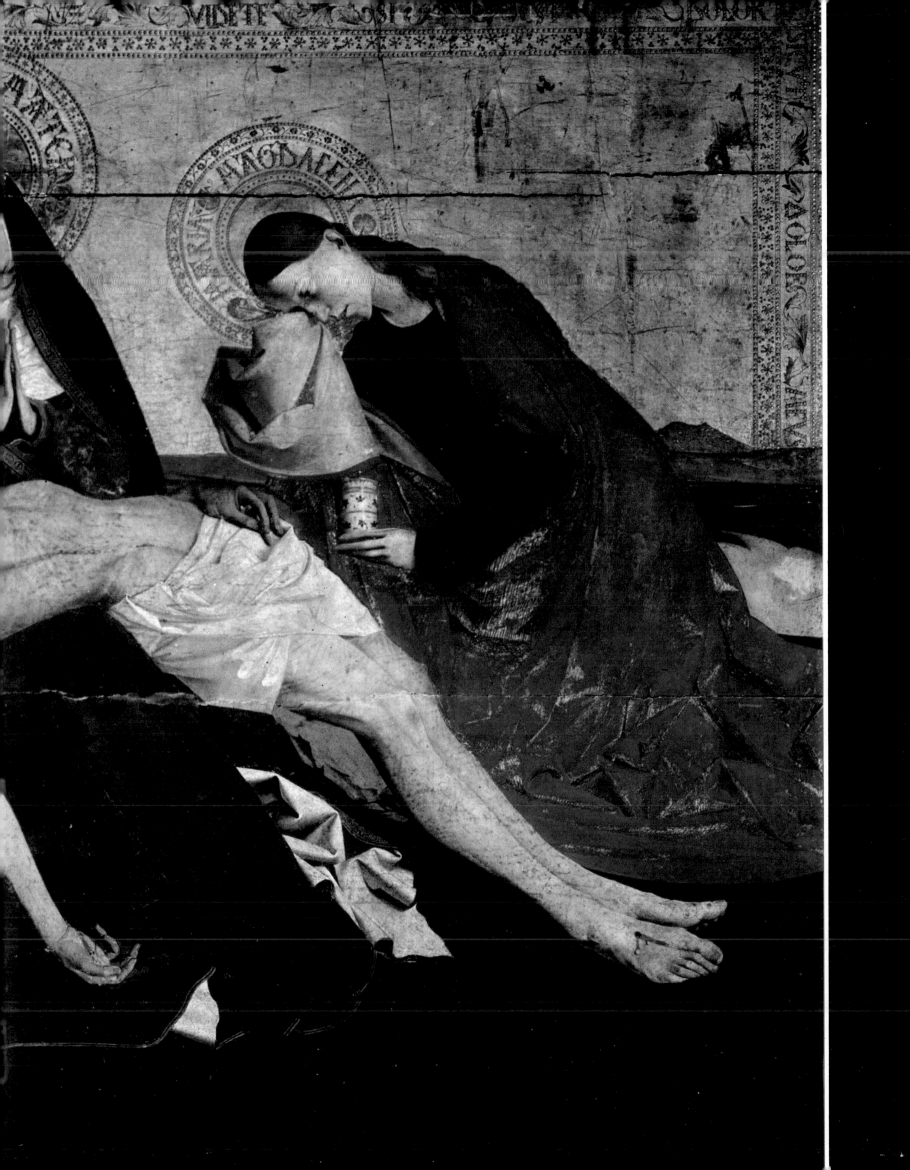

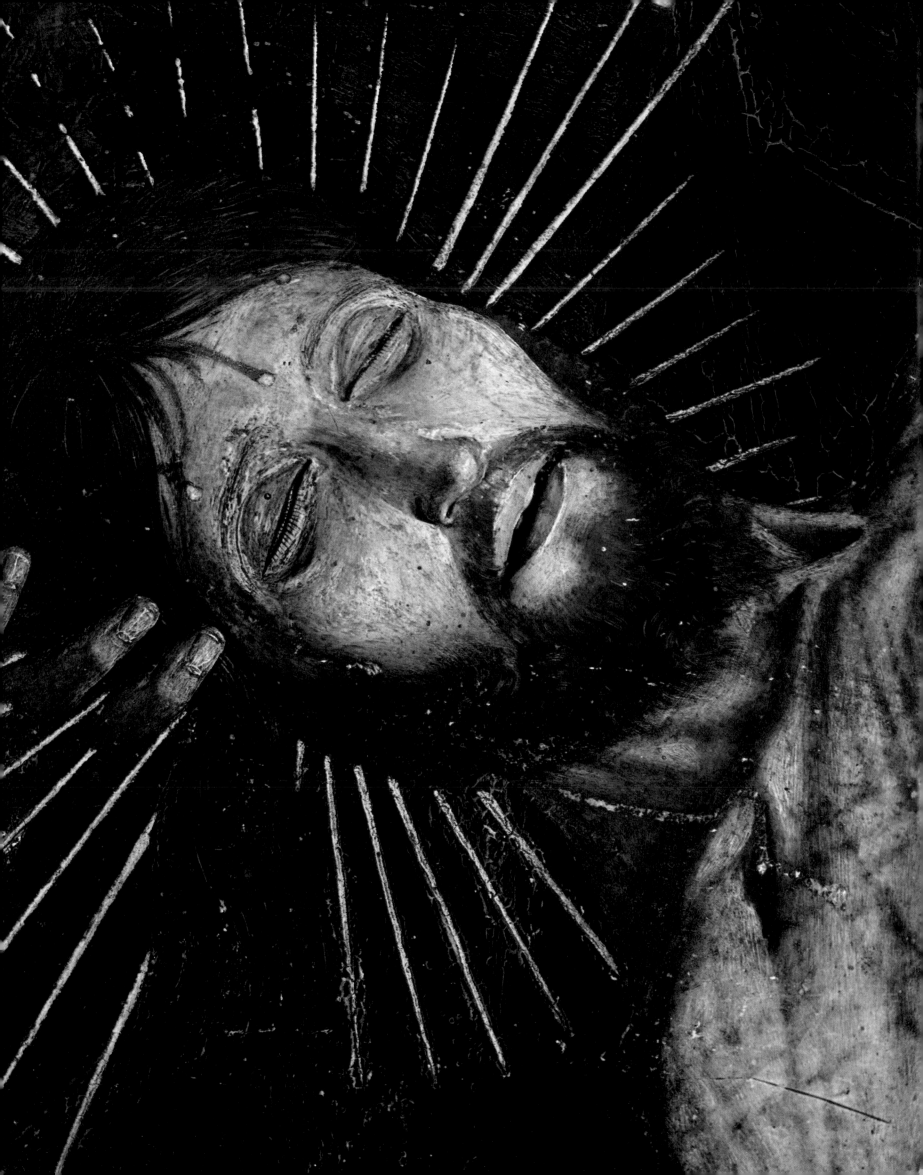

1700 are even now confused with their Netherlandish or Italian counterparts. Until the end of the seventeenth century France has to be seen very much more in a wider European context. Later, the painters became less susceptible to outside influences, thus producing what, in terms of modern criticism, was a much more national style.

Artistic production in the late Middle Ages was curiously unsettled. This was despite the fact that almost every town, whether large or small, was dominated by a recently erected Gothic church or cathedral; large numbers of manuscripts were produced in the cloisters, exquisitely illuminated — indeed the first years of the fifteenth century saw the production of the most perfect of all illuminated manuscripts — the *Très Riches Heures du Duc de Berry*. However, France was the scene of a power struggle. The English monarchy was seeking to take territory from the French king, and although the period, dominated by Joan of Arc, makes an exciting and moving story, it spelt virtual disaster for artistic production. Each part of France was isolated from its neighbours — most of the fighting took place in the rich areas of the west. The south, relatively peaceful, naturally looked towards the Italian states. Nice (Nizza) did not become part of France until the nineteenth century. East of the centre, the Duchy of Burgundy maintained its powerful independence until the death of Duke Charles the Bold in 1477 at the battle of Nancy — an event depicted in full Romantic fashion 350 years later by Delacroix (the painting is appropriately in the Musée des Beaux-Arts at Nancy).

The Duchy of Burgundy was important not only because it occupied an immense proportion of eastern France, but also because of its sovereignty over large areas of The Netherlands. The Burgundian court was one of the chief patrons of Jan van Eyck and it is this dual culture, the Burgundian and the Netherlandish, under one ruler that was basically responsible for the dissemination of early Netherlandish painting all over France, both in the form of the export of actual pictures, and in stylistic influence on native painters.

Paris played a relatively unimportant role in this period, and much dispute has continued as to whether the few surviving pictures from this time were painted in Paris or Burgundy. Very few names of painters have survived, and most productions are usually identified as by 'The Master of . . .'

The painters in the south, although influenced by Italian models, may have had Northern origins. The chief influence on most painting of the period was the powerful artistic personality of Simone Martini. This great Sienese painter had been called to the exiled Papal court in Avignon in the 1340s and left behind a considerable corpus of work, most of which is now destroyed, though a very faded fresco can still be seen in the cathedral of Nôtre-Dame des Doms at Avignon. His influence was to last for a hundred years.

The painter of *The Avignon Pietà* is still not certainly known, although he is now thought to have been Enguerrand Quarton. In any case, the *Pietà* remains an exceptional work of art by any standards. But its uniqueness is an indication of the lack of real tradition in the south. The same is also true of the Aix *Annunciation*, a splendid altarpiece, the centre panel of which is still in the church for which it was painted at Aix-en-Provence. The painter could well have been a Northerner, and it is possible to detect the influence of Jan

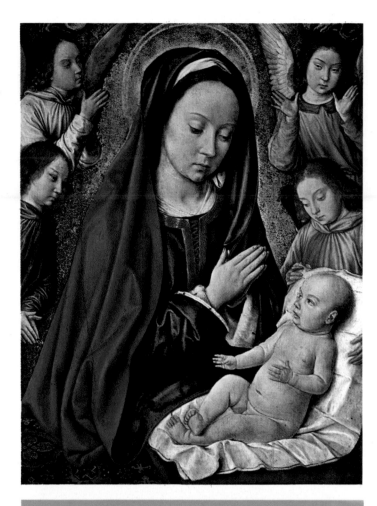

Master of Moulins: *Virgin Adored by the Angels*, 38·5 × 29·5cm, and detail, 1490s

There has been much discussion about the origins and identification of the Master of Moulins, who is considered by some scholars to be Jean Hey of Brussels. Even if this identification should prove incorrect, many of the pictures attributed to the Master of Moulins are very close in style to Netherlandish work of the last years of the fifteenth century. The painter is named after the great altarpiece painted for the cathedral of Moulins, in central France, in the last decade of the fifteenth century. This *Virgin* is less imaginative than that of Fouquet and shows well the painter's meticulous technique and rather opaque paint. He was also an excellent portraitist.

van Eyck in the precision and attention to detail. In the duchy of Burgundy and at the French court in Paris very different influences prevailed. First, there was the art of manuscript illumination, which caused some painters of small devotional pictures to imitate the style and technique of illuminated manuscripts. Second, there was the influence of the Flemish Jan van Eyck, who worked for the Burgundian court and whose influence can be seen in such pictures as the *Virgin Adored by the Chancellor Rolin*, in the Musée Rolin at Autun, by the still anonymous Master of Moulins. (Rolin

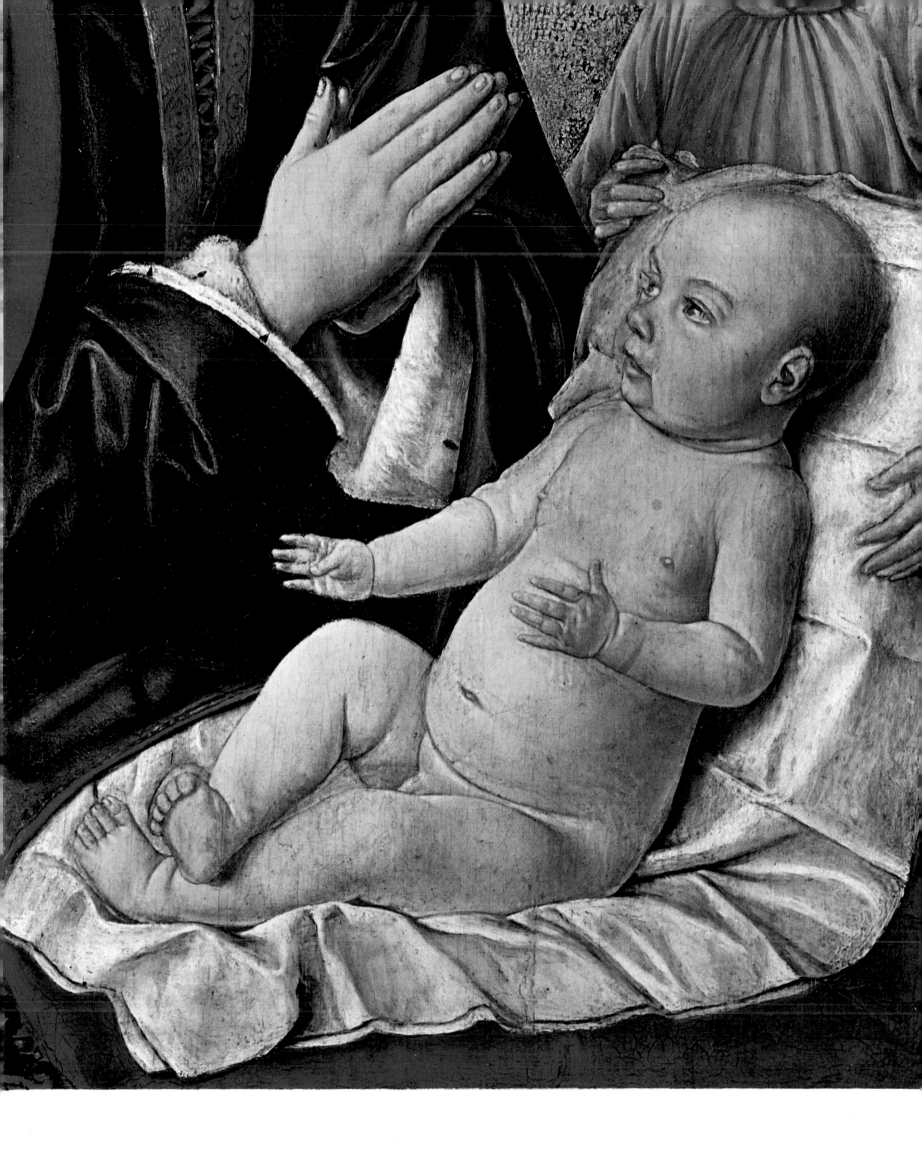

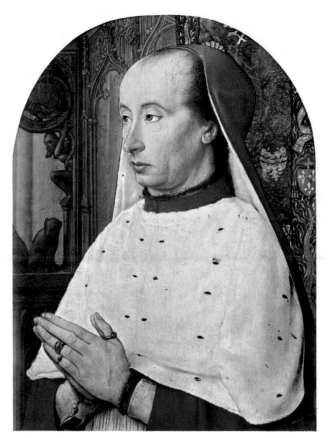

Master of Moulins: *Charles de Bourbon*, 37 × 27cm, c.1485

The reign of Francis I (1515–47) had several important consequences for painting in France. First, it seems that the local schools were losing their traditions even in the first half of the sixteenth century. This was in total contrast to the Flemish cities, especially Douai (then in Flanders), Ghent, Antwerp, Brussels, Leiden and 's-Hertogenbosch, where great painters worked throughout the first half of the sixteenth century. Francis I was conscious of this lack of activity, and even talent, and it was with great difficulty that he persuaded the ageing Leonardo da Vinci to come to France. Leonardo brought with him, even in old age, a mind and hand totally out of keeping with his times. His presence in France also caused some of his most important works to

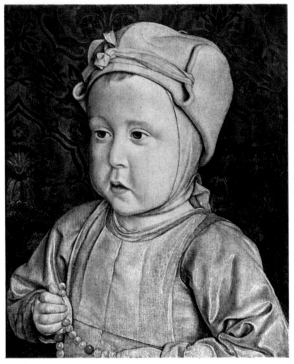

Master of Moulins: *The Dauphin Charles Orleans*, 28 × 23cm, c.1494

appears in the celebrated Jan van Eyck painting in the Louvre). The Master of Moulins was certainly a Fleming who worked in the centre of France – his most important picture being the elaborate altarpiece in Moulins Cathedral.

One of the few court painters of the fifteenth century whose works survive is Jean Fouquet. His famous *Virgin and Child* is said to represent Agnes Sorel, the mistress of Charles VII (the Dauphin). Born in Tours, Fouquet was very strongly influenced by Flemish painting and acquired a Northern sharpness of touch.

Near the Flemish border, Amiens was a centre of patrons – the city was wealthy enough to support painters, chiefly for the religious institutions. These Amiens painters were characterized by their elaboration of both figures and decoration. The result may be in the final analysis provincial, lacking the tautness of the nearby Flemish painters, but the accidental survival of the Amiens pictures is a further illustration of the tantalizing way in which history is presented. Very little remains from the other towns in the north that were rich at that time.

Taken as a whole, this does not amount to very much. Only a few dozen pictures of merit survive, although their quality is very high. They have been neglected in the past, and it was not until an exhibition was held in Paris in 1904 that French paintings of this period were properly recognized. Certainly much has been lost. The pictures must be looked on as curious survivors and cannot be fitted into a proper pattern through lack of evidence, but they bear witness to the fact that painting flourished all over the country in centres largely unconnected with one another.

The Master of Moulins cannot rival his Flemish contemporaries, Hugo van der Goes or Gerard David. He lacked both their finesse and their intensity. This, however, should not allow his art to be neglected. He had a direct power of observation – his portraits depict very strongly the character of the sitters, following in the tradition of Jan van Eyck.

Jean Fouquet: *Virgin and Child*, 91 × 81cm, and detail (Page 14), c.1431

Like many of his contemporaries, Fouquet remains an enigmatic figure. His exquisite style of both his paintings and his manuscript illuminations was based on Netherlandish models. In spite of his bright colour and meticulous modelling, Fouquet's art cannot be mistaken for Netherlandish as he has a curiously different temperament. The Virgin is baring her breast in an obviously sexual way. A use of considerable imagination is found in the treatment of the impish and highly coloured angels in the background. The sitter has been thought to be Agnès Sorel, the mistress of Charles VII, and while this identification is uncertain the painting provides some insight into the informality of the French Court at the time. The *Virgin* is believed to be one panel of a diptych, the other half of which is in Berlin and depicts Etienne Chevalier and St Stephen.

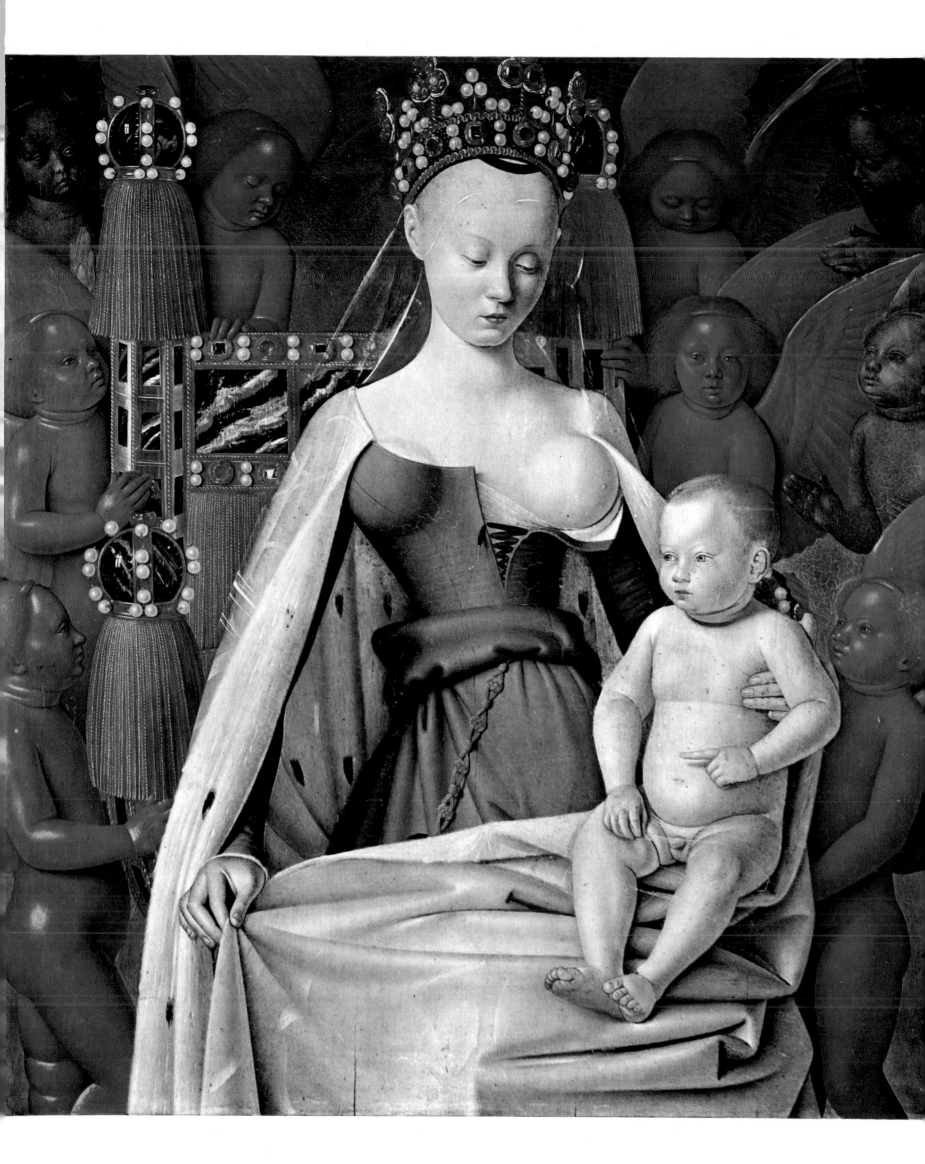

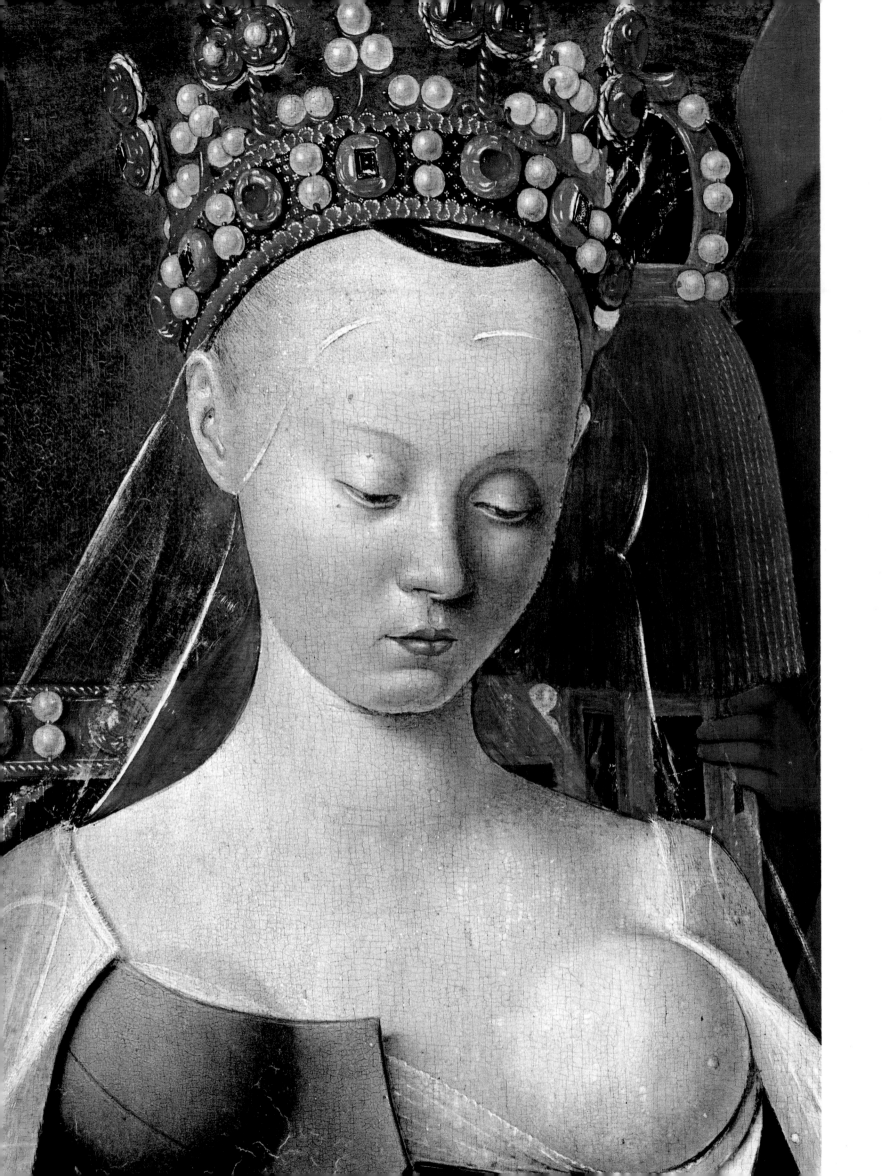

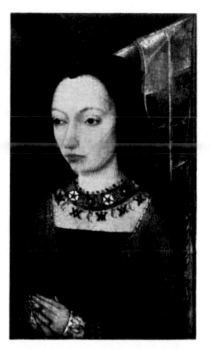

Fouquet: *Etienne Chevalier and St Stephen*, 93 × 85cm, c.1443

French School: *Margaret of York*, 20·5 × 12·2cm, c.1468

Although Leonardo's contribution to painting in France at the time was minimal, Francis I was able to entice Francesco Primaticcio to France to decorate the palace of Fontainebleau. His scheme, which consisted of sculptures as well as paintings, exerted a profound influence, directly for fifty years, and indirectly as a precedent for the vast decorations of galleries, culminating in the Grande Galerie of the Louvre, which was never completed. Primaticcio worked in an extravagant Mannerist style that was at once refined and

arrive in the French royal collection. This event had little significance at the time, but the presence of the *Mona Lisa*, *Leda and the Swan* (until the prudish Madame de Maintenon destroyed it at the end of the seventeenth century), the *Virgin of the Rocks*, *St John the Baptist* and *La Belle Ferronnière* was to act as an inspiration and influence on painters who had access to the court. This was true especially in the seventeenth and eighteenth centuries, and Leonardo's influence can be seen directly and indirectly in painters as different from one another as Lubin Baugin, the seventeenth-century artist known as 'Le petit Guide', and Prud'hon.

Simon Marmion: Part of the *Altarpiece of St Bertin*, 56 × 147cm, 1459

French School: *Coronation of the Virgin*, diameter 20·5cm, early 15th century

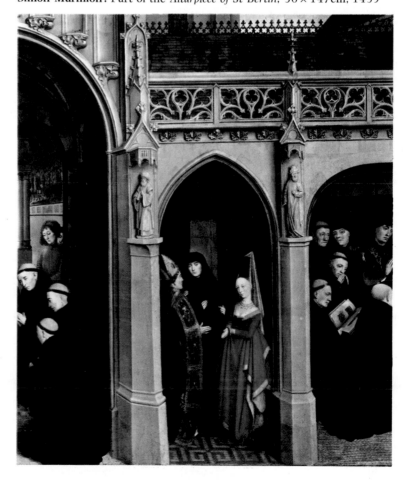

exaggerated. A perfect example of this type of art is his *Rape of Helen*. The whole surface is covered with agitated figures, the forms are rounded and totally Italian in feeling, and the colour is cool and grey.

Nothing could be a greater contrast to this than the work of the native painters employed by Francis I. They concentrated almost exclusively on portraits. By far the most talented was the earliest, Jean (or Jehan) Clouet, whose small and brilliantly painted portrait of Francis I sums up that monarch, just as the work of Holbein sums up the French king's contemporary, Henry VIII of England. Most of the work of the Clouet family has to be studied from the numerous surviving drawings (many of which are in the Louvre and in the Musée Condé, Chantilly) as their paintings are extremely rare. Françouis Clouet, the son of Jean Clouet, continued the tradition of his father throughout the reigns of Francis I and his three sons, Henry II, Francis II and Charles IX, who ruled after him. A clear impression can be gained of the rather poor level of artistic achievement compared with that of Italy or Flanders. However weak from the artistic

Primaticcio: *The Rape of Helen*, 155·6 × 188·6cm, 1530s

Pictures from the School of Fontainebleau, although undoubtedly produced in very considerable numbers, are now extremely rare. The exact site for which this picture was intended is not known, but the general subtle colours based on pinks and greys implies that it formed part of a general scheme of decoration involving stucco and sculpture, as in the famous gallery at Fontainebleau, executed for Francis I by Primaticcio himself. The attribution of this picture has been disputed in the past, although Primaticcio is the obvious candidate, which illustrates the ability of the painter to lose his personal character when executing a canvas having a decorative purpose. Most of the elements in the composition are standard Italian motifs used by the previous generation of Pontormo and Rosso Fiorentino.

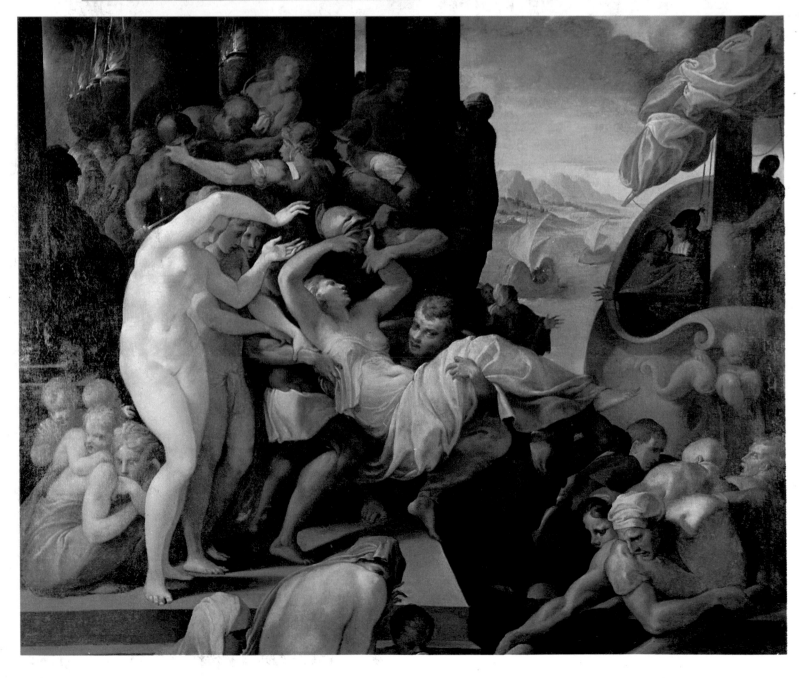

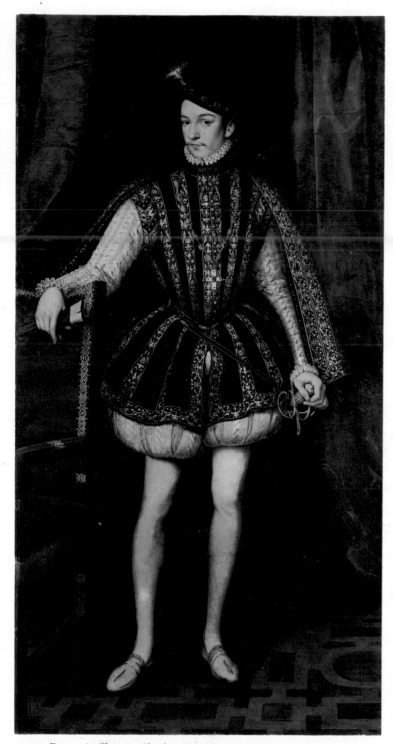

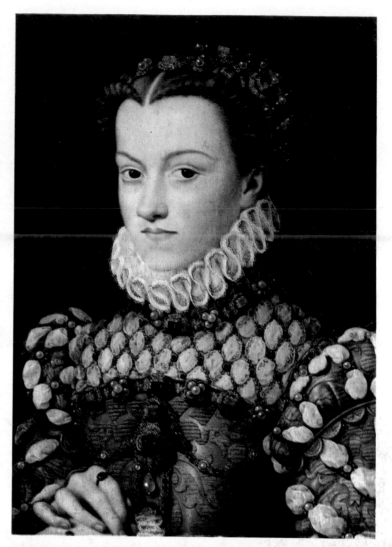

ABOVE **François Clouet**: *Charles IX*, 222 × 115cm, 1569

ABOVE RIGHT **François Clouet**: *Isabella of Austria*, 36 × 27cm, early 1570s (before 1572)

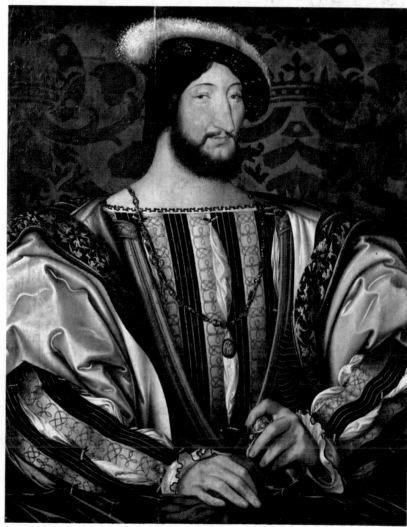

Right **Jean Clouet**: *Francis I*, 74 × 26cm, 1530s

Barely half a dozen pictures survive from the hand of this court painter of the reign of Francis I. Yet in technique and power of observation, Jean Clouet rivals his German contemporary, Hans Holbein. In this picture the lavishness and grandeur of the French monarch is captured in every detail. At this time it had suddenly become the fashion for painters to be commissioned to produce large numbers of official portraits. The German princes had Cranach, the English monarchy chose Holbein, and Bronzino recorded the Medici family in Florence. It is only in recent years that this picture has been accepted as being by Clouet, and many other attributions, even to Italian painters, have been suggested.

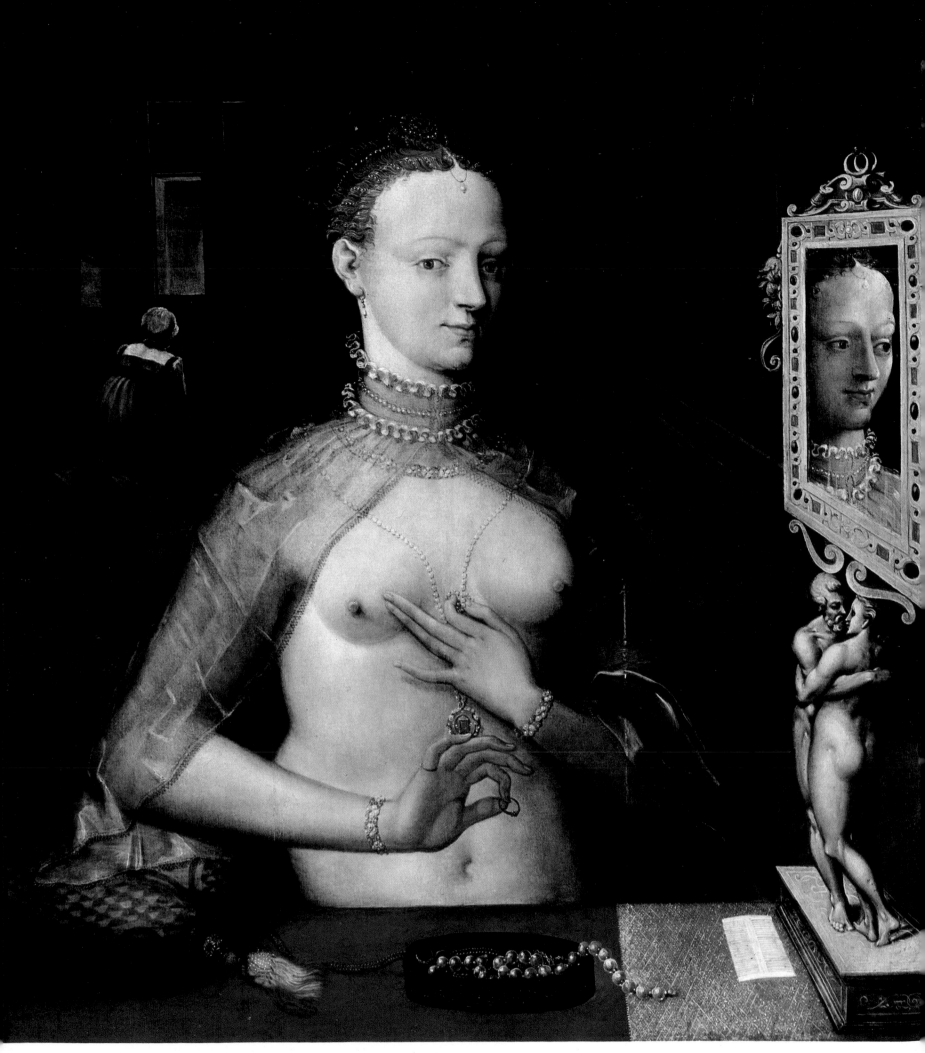

School of Fontainebleau: *Diane de Poitiers,* 11·5 × 98·5cm, c.1550

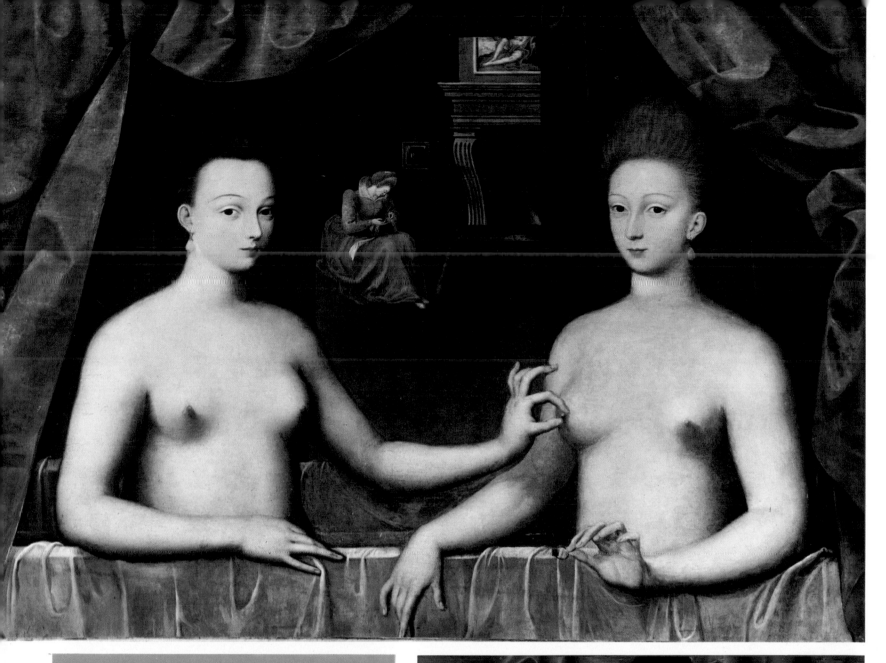

Above **School of Fontainebleau:** *The Duchesse de Villars and Gabrielle d'Estrées in the Bath*, 96 × 125cm, c.1594

Gabrielle d'Estrées was the mistress of Henry IV and this picture's subject has been interpreted as the Duchesse de Villars indicating with her finger the future birth of one of the king's natural sons. From the point of view of style the anonymous court painter of this engaging picture had rejected all Italian influence and had produced his own, rather homespun, version of an erotic subject. The lessons of Primaticcio were by this time half a century old and were gradually being diluted. This type of picture had no subsequent influence. In the following century a totally new style began under the influence of the main characters at the court of Louis XIII, Henry IV's successor.

RIGHT **François Clouet:** *The Bath of Diana*, 78 × 110cm, 1560s

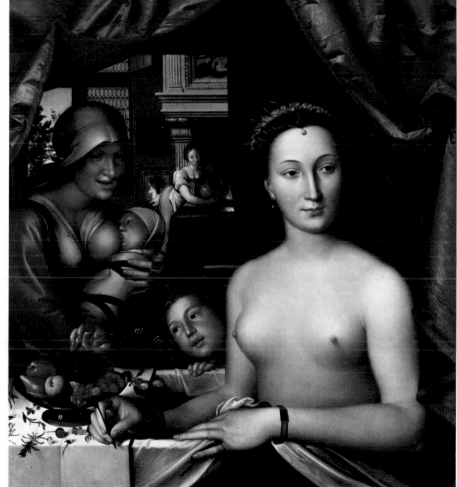

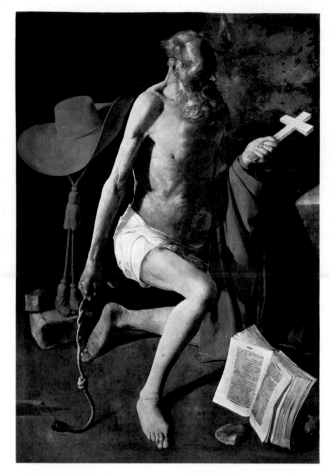

Georges de La Tour: *St Jerome*, 153 × 106cm, c.1630

point of view, these paintings either by members of the Clouet family or by anonymous contemporaries, described as 'School of Fontainebleau', have a tremendous visual and historical interest. Paintings like *The Duchesse de Villars and Gabrielle d'Estrées in the Bath* give a clear insight into court life of the period. The difference between the French court of the period and that of Philip II of Spain could not be more marked. Philip, for all the faults attributed to him, collected the works of Hieronymus Bosch with enthusiasm and was one of Titian's chief patrons, although Francis I, to his credit, had also commissioned a portrait from Titian.

Thus as the sixteenth century drew to its close, with the tolerably peaceful reign of Henry IV after the turbulence of the previous three reigns, artistic activity languished. Henry

La Tour: *Christ in the Carpenter's Shop*, 132 × 98cm, c.1640

This is perhaps Georges de La Tour's most accomplished picture. His handling of the light is at its most subtle in the way it flickers over the faces of the two figures. La Tour's preoccupation with unusual effects of candlelight accounts for the way the dirt in the Christ Child's fingernails is seen reflected through the hand held against the light. But La Tour does not concentrate exclusively on realism. The pose of the aged Joseph is exaggerated — his back produces a great arch across the top of the picture as a device to improve the composition. In a picture of this type La Tour's unique contribution to the whole history of art becomes apparent. The relative isolation of Lunéville allowed him to produce totally personal pictures, which owe very little to outside influences.

IV was a man of immense practicality, much more concerned with setting the country to rights politically and economically after almost half a century of internal disturbance and weak government. His major artistic contribution was the construction of the Place des Vosges in Paris, rather than elaborate decorative cycles or the invitation of prestigious foreign painters to his court.

As a consequence, the lack of artistic achievement must have made Paris a drab capital in those years. The assassination of Henry IV in 1610 ushered in a new period — the reign of the enigmatic Louis XIII. This monarch has never been properly assessed from the point of view of his influence on the arts. He was considerably dominated by his mother, Marie de Medici, who commissioned, for her own glory, the incredible cycle by Rubens extolling the virtues and the reign of her late husband, Henry IV. Although it could not have been realized at the time, this immense series of paintings, conceived for the Luxembourg Palace (and now in the Louvre) became the greatest influence on French painters for the next two hundred years. Marie de Medici also favoured another Flemish painter at her court, Frans Pourbus II, who contributed a polished Flemish style of portraiture. Small wonder that the monarch himself appears a nonentity against this glittering backdrop of his mother's artistic interests, political machinations, and powerful personality. The chief minister was the brilliant and taciturn Richelieu, himself a collector of paintings, and it was under his influence France began to expand towards its present territorial frontiers.

If the court was dominated by foreign artists (yet another

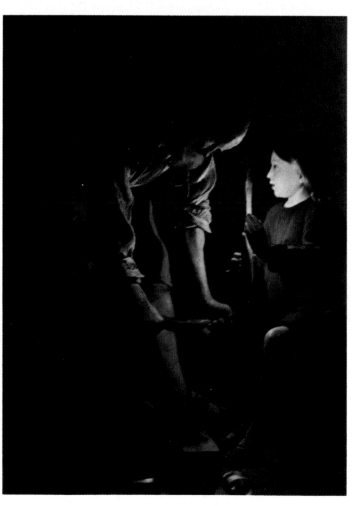

OPPOSITE **School of Fontainebleau:** *Diana the Huntress*, 192 × 133cm, c.1550

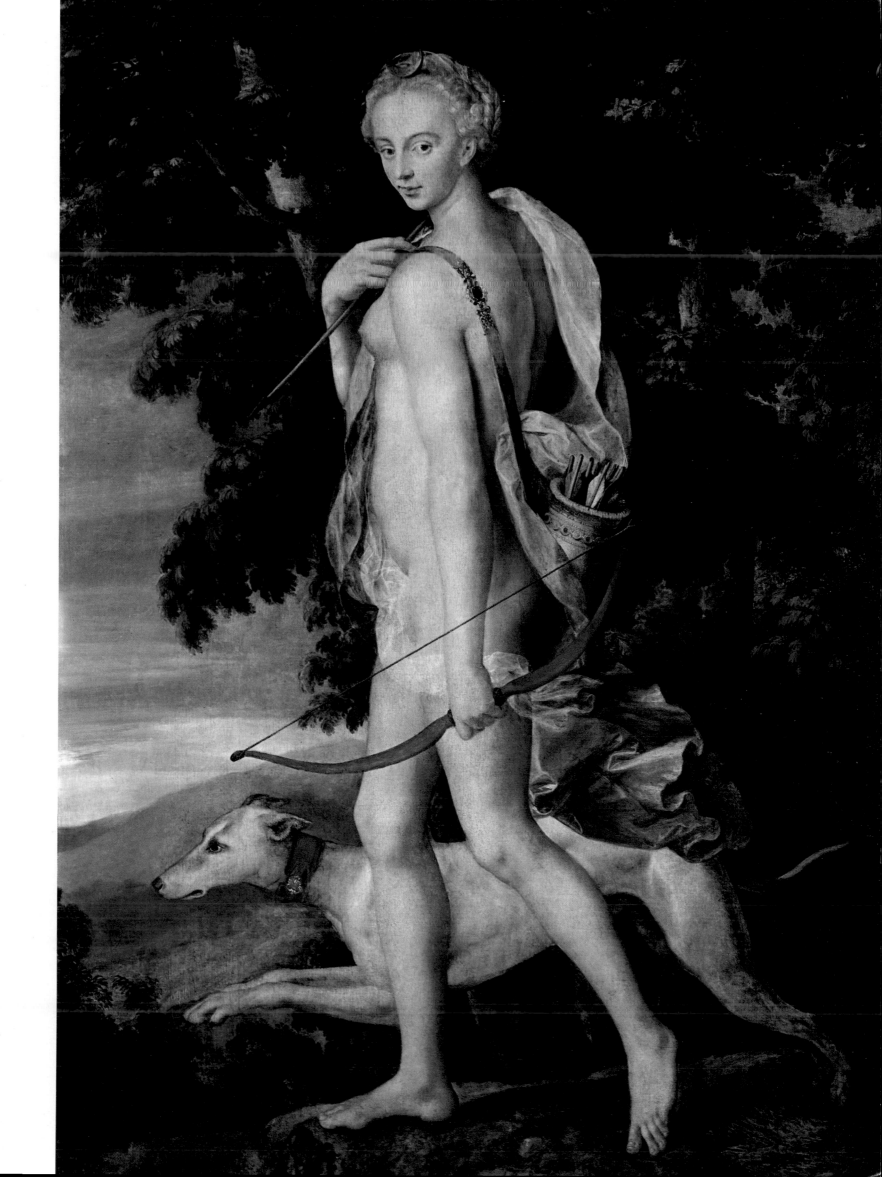

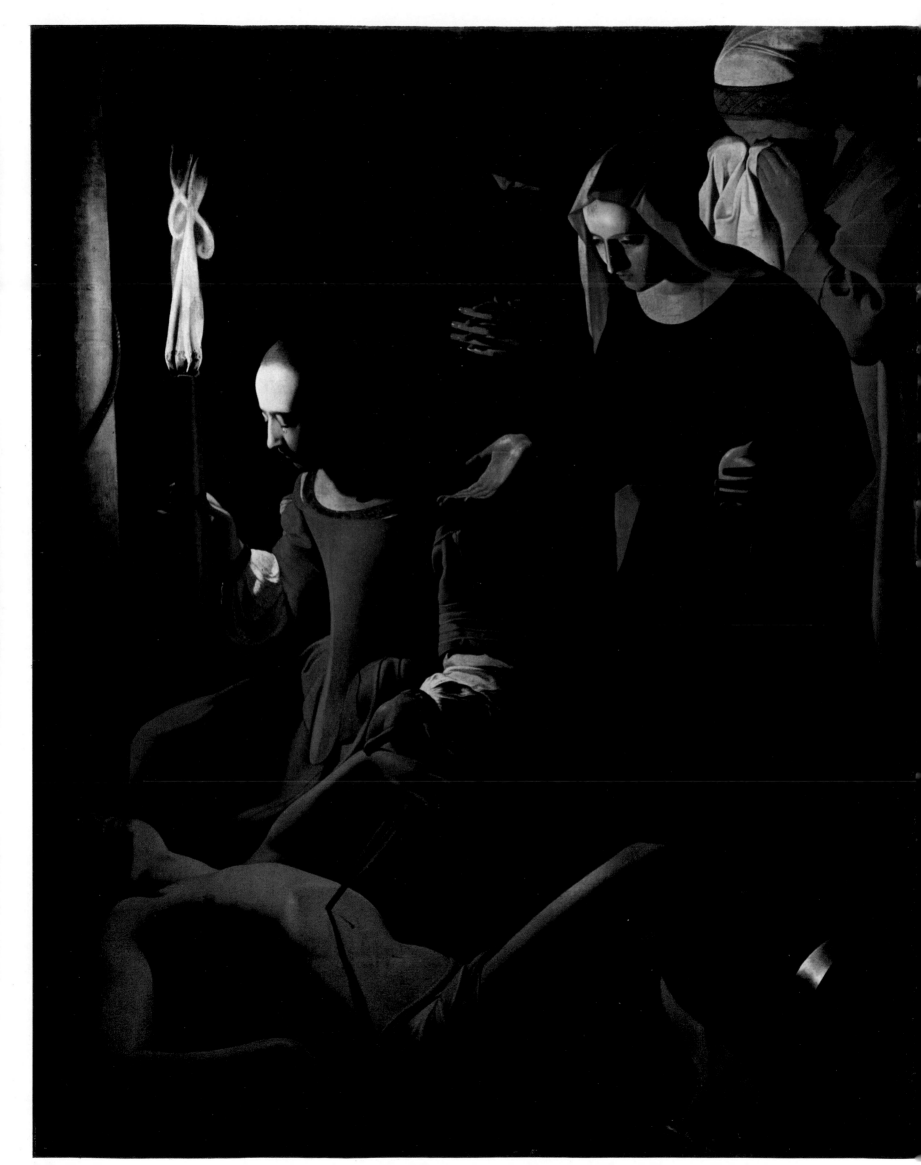

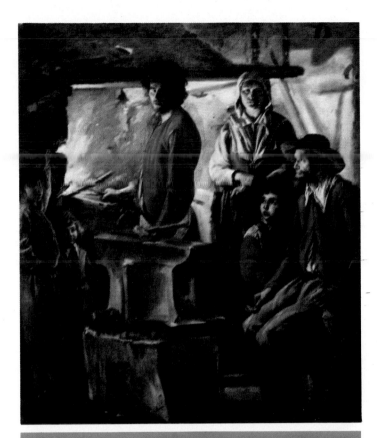

Le Nain Brothers: *The Forge*, 69 × 57cm, 1640s

The Forge sums up the uniqueness of the Le Nain brothers. Largely eschewing other forms of painting — there are a few experiments with religious and allegorical pictures — they concentrated on peasant genre. Here the theme of Venus at the forge of Vulcan, so popular at the time, is transformed into a simple scene of peasants at a forge. As in life, the sitters look in different directions and are not made to react to each other. This is exactly as if they were being recorded by a modern, unposed snapshot. The ability to record the individuality of each peasant in a totally detached way makes the brothers unique in their time.

Fleming, the now obscure Jacques Foucquières, had been commissioned to decorate the Grande Galerie of the Louvre with views of French towns), the situation was rather different in the remoter provinces. In a sense there is almost a return to the position which had prevailed at the end of the fifteenth century, when each area produced a few local painters of interest who were influenced either by Flemish or by Italian models.

The south remained close to Italy in spirit, and the minor painters active there tended to be influenced by Caravaggio, and produced dark candlelight pictures such as those of the painter active in Aix-en-Provence and Arles, Trophîme Bigot (sometimes called 'The Candlelight Master'). The other region of importance was the Duchy of Lorraine. The power and influence of the Duchy of Burgundy had been destroyed at the end of the fifteenth century, and Lorraine, then part of the Burgundian empire, began an all too brief period of independent prosperity and artistic activity.

The ducal court at Nancy was provincial in the best sense of the word; contact with Italy was frequent, either through marriage or by the fact that a talented artist like Jacques Callot worked in Florence before his return to Lorraine. Lorraine produced, almost by accident it appears, a painter who has become famous three hundred years after his death — Georges de La Tour. In his time he was respected locally, and it appears that his art was appreciated by the French forces who took over Lorraine in the 1630s. But the duchy did not become part of France officially until 1766.

For the first time in the history of French painting, more than isolated fragments survive. It is possible to build up a general idea of the pattern of painting over the whole country. Certainly the individual painters were far less productive than their Dutch contemporaries, and they had fewer important commissions for altarpieces than was the custom in Italy. In this context therefore a painter such as Georges de La Tour worked in relative isolation in his province, aware from time to time of developments in Italy and The Netherlands and, as a consequence, producing his own highly personal style, which had far less to do with the demands of the patron than in Paris, where the main painters worked to commission.

La Tour's art has found a special place in the twentieth century — he has been suddenly recognized as one of the few individuals in the whole history of art who were able to make a contribution to man's experience by exploring a very limited range of subject matter. He took the night scene to an impossible extreme of calm and stylization, coupled with a delicate understanding of human nature.

The only French painter who received official recognition at this time in Paris was Simon Vouet. He had spent his youth in Rome, painting pictures influenced by Caravaggio. In France he soon abandoned this style, painting instead in a relatively weak, highly coloured decorative manner, which seems to have found favour with Louis XIII. None the less in later years, when Foucquières had failed to decorate the Grande Galerie of the Louvre quickly enough, it was Poussin who was summoned from Rome and not Vouet. Poussin was of course temperamentally unsuited for so vast a scheme and retired, defeated, to Rome after two years.

The real painters of quality tended to remain on the fringe of official patronage. The Le Nain brothers fall into this category. All three, Louis, Antoine and Mathieu, came from

Le Nain Brothers: *Peasant Family*, 97 × 122cm, 1640s

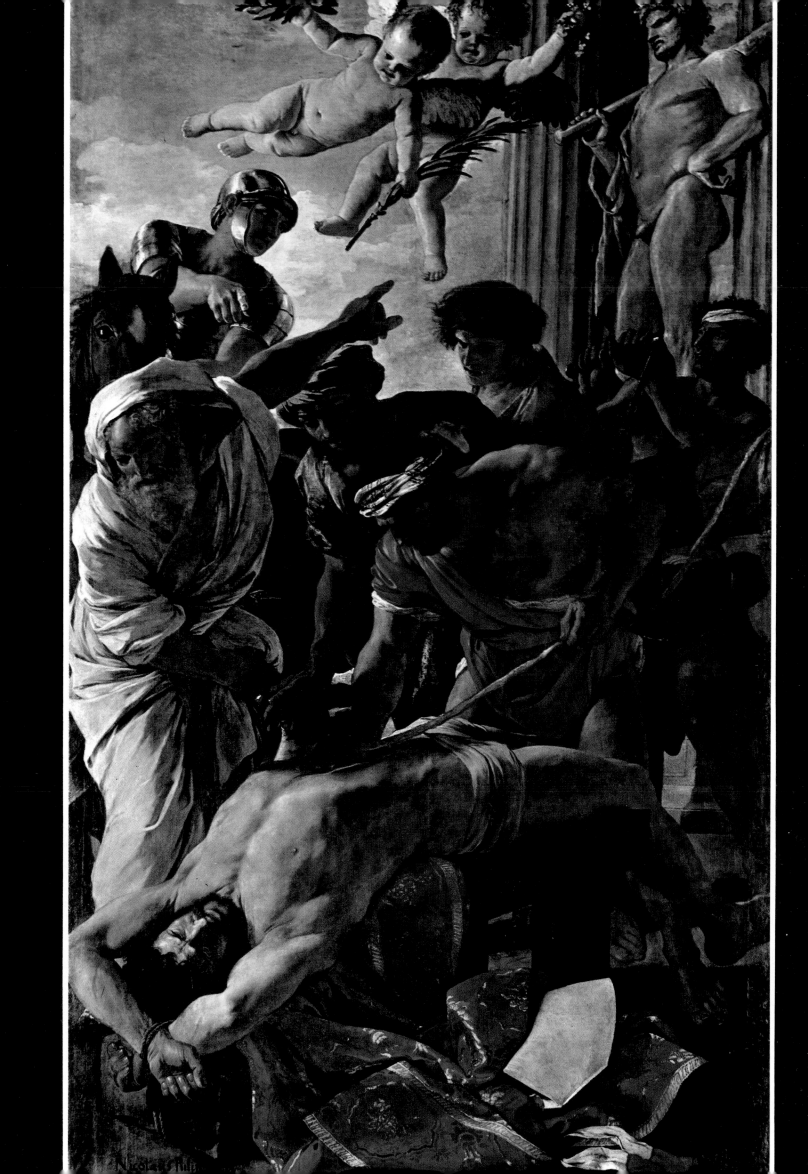

Nicolas Tulli

Opposite **Poussin:** *Martyrdom of St Erasmus,*
320 × 186cm, 1628–9

In his long career in Rome Poussin received very few
large official commissions – a type of painting to which
he was temperamentally unsuited. The *Martyrdom of
St Erasmus* was commissioned by the Pope for a
chapel in St Peter's. The young Poussin obviously
struggled in the picture to group the elements so
necessary for the success of this type of work. He was
unable to cope adequately with the elaborate interplay
of drama usual in martyrdom scenes in this period. He
was not quite sure how to relate the main figures to
each other, and it is significant that no other such
important commission was given to him. Later, when
Poussin was called to Paris by Louis XIII in order to
decorate the Grande Galerie of the Louvre, the
grandeur of the setting proved too much for him – he
was always happier on a small scale.

like Jan Miensz. Molenaer. Although the peasant interiors
and peasants in landscapes, which form a good proportion of
this output, bear a superficial resemblance to their Dutch
counterparts, the Le Nain brothers had a curiously detached
vision. They never seemed to involve themselves, as the
Dutch did, in the telling of a story. Thus their peasants
inhabit a closed world of their own, often staring into space.
They offer insight only into the *appearance* of peasant life in
France in the middle years of the seventeenth century.

Georges de La Tour and the Le Nain brothers were un-
typical of their times but remain the most appreciated today
as pure painters of life. The artists who knew great success
in their times were of very different character, and were to
exert a profound influence on many other painters for two
hundred years. The chief name is that of Nicolas Poussin,
who went to Rome as a young man in the 1620s and settled
there for forty years, painting a modest quantity of small and
medium-sized pictures, which were to be influential out of
all proportion to what was then their significance as works
of art. Poussin's chief characteristic was an incredibly high
moral and intellectual seriousness. The result was that he
thought his pictures out before painting them. His famous
statement, that pictures should appeal to the mind and not
to the eye, taken at face value, is as ridiculous as suggesting
that music should be read and not listened to. As an artist,

Laon in the north, which was then very close to the border
with the Spanish Netherlands. They collaborated on many
of their pictures and the few that have been signed bear a
cryptic LENAIN. Their achievement was considerable be-
cause they brought to Paris a basically Northern style of
painting, very close to that of the Haarlem genre painters

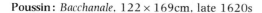

Poussin: *Bacchanale,* 122 × 169cm, late 1620s

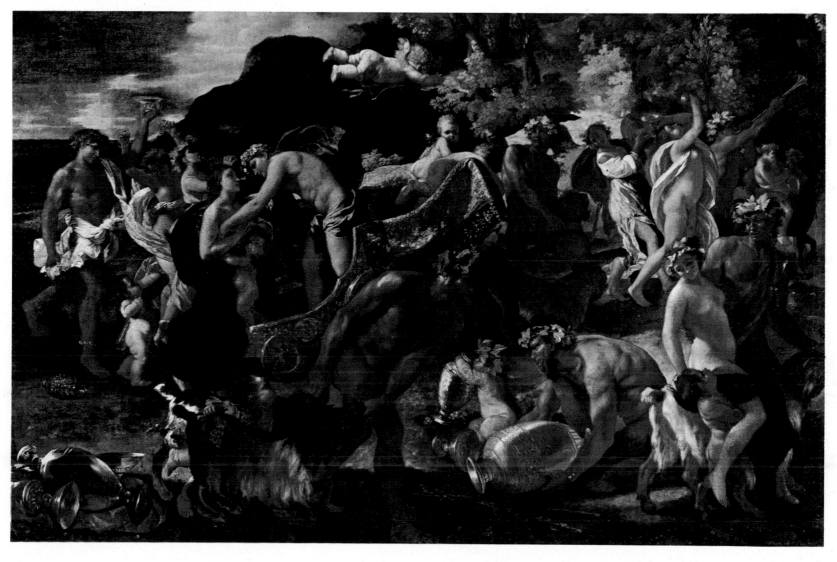

Poussin responded to nature as his drawings of the landscape around Rome show, but he removed all spontaneity from his vision in trying to create a new classical perfection based on an updating of antiquity.

For his religious pictures he read the Bible story most carefully, in order that inconsistencies should not creep in. His very seriousness meant that he was only modestly successful in his lifetime. His pictures were often bought by members of the French intellectual circles and taken back to France. Because of the literary and intellectual content of his art, Poussin became the model for academic thought in the latter half of the seventeenth century. His thoughts, ideas, and style of painting could be taught and easily imitated. Thus, right down to Ingres in the early nineteenth century, there are constant quotations from Poussin's art, in the pose of figures, in general composition and in artificially controlled colour schemes.

This very intensity occasionally makes Poussin's work enjoyable on a very different level. The thought behind the

Poussin: *Moses Saved from the Water*, 85 × 121 cm, 1638

In this picture Poussin has tried to adhere as exactly as possible to the Bible story, making it clear that the event took place in ancient Egypt by introducing the pyramid in background, on the right. The painting marks a turning point in Poussin's stylistic development from his much more Baroque and Venetian-influenced early compositions to the severe classicism, which was to dominate his art for the last thirty years of his life. The grouping of the figures is especially dense, and the gestures are carefully calculated to increase the obviousness of the story. For instance both Pharaoh's daughter and her attendant are pointing to the infant Moses.

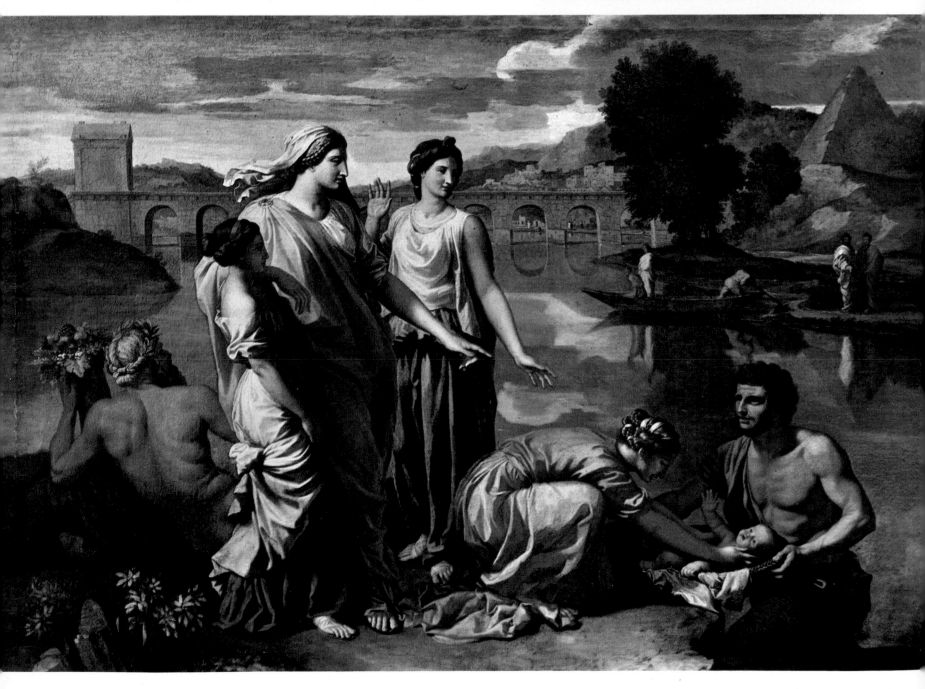

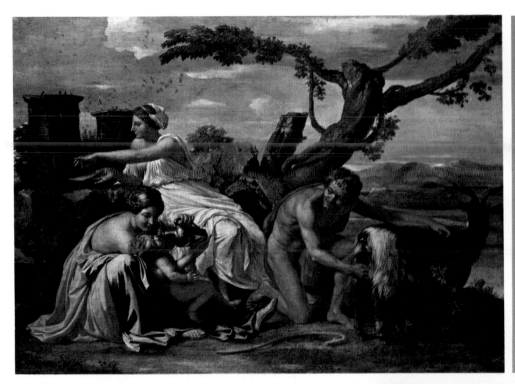

Poussin: *The Nurture of Jupiter*, 97 × 133cm, c.1640

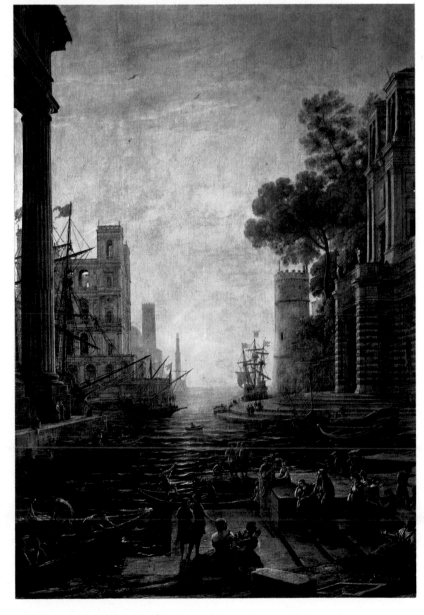

Below **Claude:** *The Embarkation of St Paula*, 211 × 145cm, mid-1630s

Between 1634 and 1638 Claude painted a series of decorative canvases for King Philip IV of Spain, intended for the Buen Retiro Palace. Although the upright format is unusual for Claude, the scene is typical of those he preferred in the early part of his career. He liked to balance the two sides of the picture with fragments of classical architecture and ships, using the centre of the picture to show his preoccupation with the rising or setting sun. The subject, an unusual one in seventeenth-century painting, plays a very secondary part in the picture, which is essentially a study of light and atmosphere.

picture is often so strong, the searching for an impossible order so passionate, that at the end of his life Poussin was able to produce such an original group of pictures as *The Four Seasons*, in the Louvre. They have been shown to have several levels of meaning as allegories. But even taken individually, each one becomes a totally personal statement based on a direct observation of nature. *Autumn* is gently mellow, and *Winter* ('The Deluge') an original picture without precedent or successor. Poussin here created a feeling of dark despair, of eternal rain. His search for truth always led him to an extreme.

Poussin's compatriot in Rome at the time was Claude Lorrain, the complete opposite of Poussin in many respects. He seems to have read but little and was patronized by the Roman aristocracy. Almost all his output consists of idyllic landscapes and seaports. Some of his pictures include incidents from the Bible or Virgil's poetry, but the subject is always played down in order to concentrate on the landscape. Claude's art was instantly appreciated, and he became much sought after. Like Poussin, he would slowly build up his visions of an impossibly perfect world bathed in morning or evening light.

Claude's art became just as influential as that of Poussin, but with different effects. Landscape painters especially in France and England in the eighteenth century could not help composing their pictures and lighting them, not according to nature, but according to the way Claude had arranged it. Thus his similarity to Poussin is that he strove to achieve an artificial perfection, and eschewed a direct approach to the world.

Even though there was far less activity of painting in France in this period, there were several painters of immense talent whose reputations have often been obscured by the scattering of their work during the French Revolution, or for the simple lack of an apologist. One of these is Louise Moillon, who had a long career in Paris as a still-life painter. The

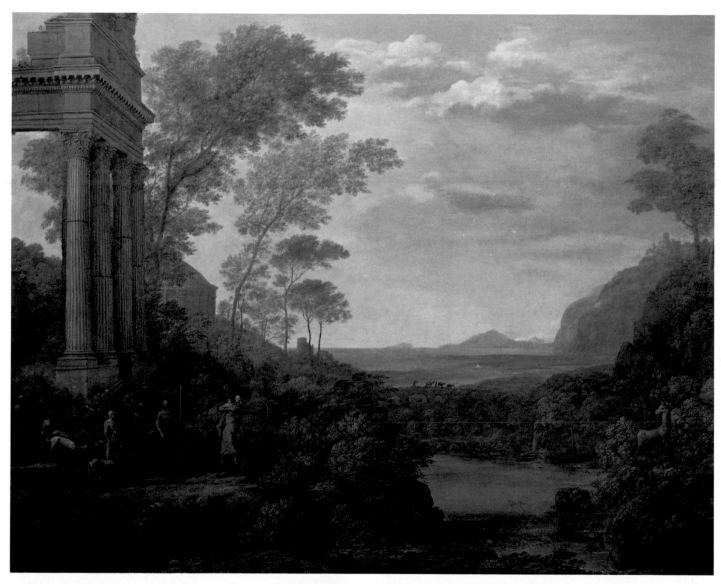

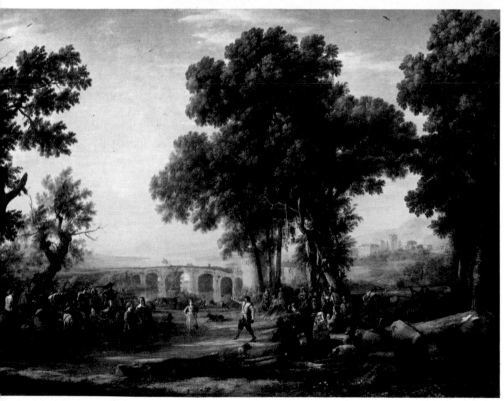

Above **Claude:** *Ascanius Shooting the Stag of Sylvia,*
120 × 150cm, 1682

Claude was quite the opposite of Poussin in that he
did not have the latter's intellectual interests. They
were in fact neighbours, and it is known that they
occasionally took 'a small glass of good wine' together.
In this picture, the last by Claude, painted in the year
of his death at the age of 82, all his favourite elements
are brought together. These are classical ruins sur-
rounded by vegetation, elongated figures placed for
decorative effect, and, most important of all, atmos-
pheric light. On close inspection Claude's pictures
often appear to have rather hesitant handling, and yet
he succeeded in producing a unity of atmosphere. In
this picture the mood is one of tragedy. Ascanius is
about to shoot the pet stag of Sylvia, and this accident
led to a bitter war. The poetic melancholy is quite in
keeping with the story.

LEFT **Claude:** *The Village Fête*, 103 × 135cm, 1639

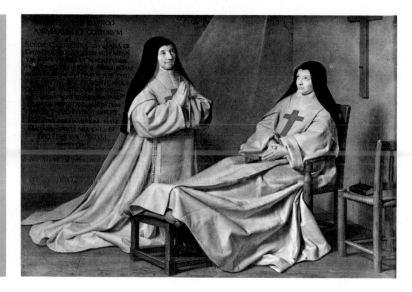

de Champaigne: *Ex-Voto,* 165 × 229cm, 1662

Much of the art of Philippe de Champaigne betrays his Flemish origins. His preference for the elaborate arrangement of figures, elaborate poses and bright colour are all part of this background. As he grew older these elements became increasingly subdued and then disappeared altogether from his art. The *Ex-Voto* has a deeply personal significance for the painter as it commemorates the miraculous cure of his daughter from paralysis when she was in the Jansenist Convent of Port-Royal. In this picture the figures are over life-size and overwhelm the spectator with their quiet simplicity.

standard she achieved was easily equal to that of her Dutch and Flemish counterparts, but, like the Le Nain brothers, she had a curious distance from her subject. It is this lack of involvement with the subject, this observation from the outside, that can be said to be the chief characteristic of French art of the period. In other words, an unsympathetic critic could describe it as a lack of warmth. The best example of a painter who completely froze his subjects is Philippe de Champaigne. As a young man he had come from Brussels, importing a realistic, Flemish-oriented art. As he grew older his colours grew drier and more like those of Poussin, and his compositions very much simpler. In middle age he was converted to the philosophy of Jansenism after the miraculous cure of his daughter in the Jansenist convent of Port-Royal. To commemorate this event he painted the *Ex-Voto,* in the Louvre.

The picture that resulted is one of the least lovable of all masterpieces. There is very little colour, only the bright red of the crosses. The two figures fill the whole surface of the picture and yet through sheer intensity of will-power as it were, the artists conveys his intentions so convincingly that the miracle seems to be taking place, exactly as it did in life, without the tangible appearance of angels and saints.

If the first half of the century had basically been a period

Louyse Moillon: *Still Life with Cherries, Strawberries and Gooseberries,* 32·5 × 49cm, 1630

Rigaud: *Louis XIV*, 279 × 190cm, 1701

Of all the images of the absolutist monarch, Louis XIV, Rigaud's portrait is one of the most telling. Much is known about Louis XIV's way of life and methods of government because so many people were impressed and astounded that they wrote about them. Often in formal portraiture the sitter is lost amongst the trappings of his office. However, in this picture Rigaud never let his preoccupation with outward glitter overcome his ability to show the sitter's real character. Louis emerges as a man of immense energy. In private life he wept often.

Bourdon: *Queen Christina of Sweden*, 72 × 58cm, early 1650s

On the whole, French painters had few connections with countries in Northern Europe. The main exception was Sweden where in the eighteenth century especially many French painters found patrons. For the seventeenth century Bourdon is unusual since he was court painter to the redoubtable Queen Christina in the early 1650s. Even so Bourdon remained quite untouched by Northern influences, and the gentle outlines of this portrait are quite typical of the rest of his portraiture. Indeed little of the sitter's forceful character emerges through the subtle greys and browns. Christina spent the latter part of her life in a self-imposed exile in Rome surrounded by the library and artistic intelligentsia of her times.

of individualists — and only a few of them have been mentioned here — the assumption of personal power by Louis XIV in 1661 ushered in a completely new age.

The 1660s were a period when many important painters died (Poussin, Champaigne) and the young king made the conscious decision to encourage the arts. From the point of view of encouraging the artists' individuality the result was a catastrophe. From the point of view of programming art for state purposes the result was a brilliant success, culminating in the Palace of Versailles and its decorations — the most dazzling combination of man's skill that had so far been seen in Europe.

The painters who served the monarch's aims were not without talent. Twentieth-century taste has not been able to bring itself to appreciate the decorative interiors of a Le Brun or a Mignard because we are used to looking at works of art in isolation and not as parts of a decorative ensemble. It is only in the portraits of the period that quality can be seen in isolation. Le Brun, the king's favourite painter, covered quite literally thousands of square feet of canvas with competently executed historical and mythological subjects, quoting from the art of both Poussin and Rubens — he had before him the ever-present Medici cycle. In Le Brun's *Portrait of the Chancellor Séguier*, in the Louvre, his real abilities are obvious.

Charles Le Brun: *The Chancellor Séguier*, 92 × 120cm, c.1660

His penetration of character and ability to compose a large picture have always been admired. If Le Brun had been a real genius he would never have been made court painter. His very competence has been his downfall in the eyes of posterity. The reign of Louis XIV is summed up from an artistic point of view by a court painter of the younger generation, Hyacinthe Rigaud. From Perpignan in the south, Rigaud had brought a certain rigidity and hardness of approach which always shines through his powers of depicting opulence. He has been neglected because he created an unpopular type of art – the court portrait – that seeks to place the sitter officially in splendour. But Rigaud did this almost better than any painter before, or since, as his portrait of Louis XIV well shows.

Louis XIV's personal reign lasted for more than fifty years. It is all the more surprising that throughout this period the artistic norm remained constant. One of the reasons for this was that in order to impose rigid standards Louis XIV had reformed the old Academy, founded in 1648, and of which the Le Nain brothers had been members. An elaborate hierarchy was worked out – which types of subject (historical and mythological) were considered to be above the others. Speeches and discourses were given, and most painters sought to belong to this august body – if they did not, there was no hope of royal patronage.

The painters of this period, Charles de La Fosse, Bon de Boullongne, the Coypel family, and many others have all been neglected. Their strivings were towards the official

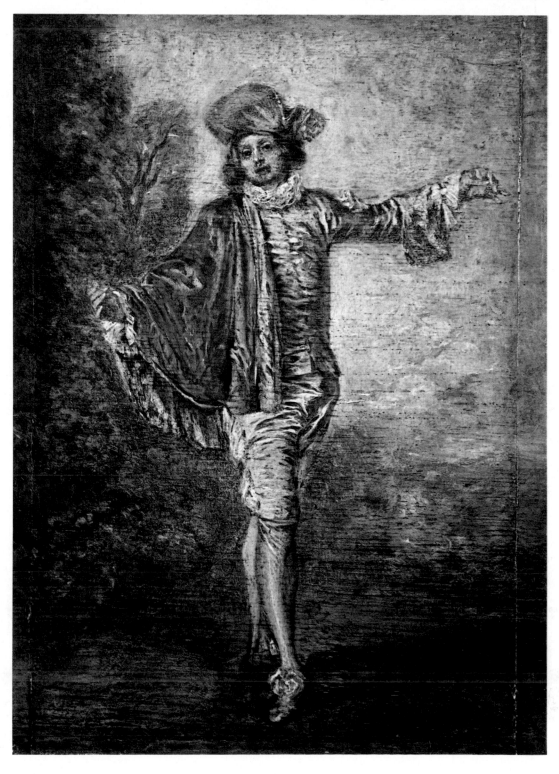

Watteau: *L'Indifferent.*
28 × 20cm, 1717

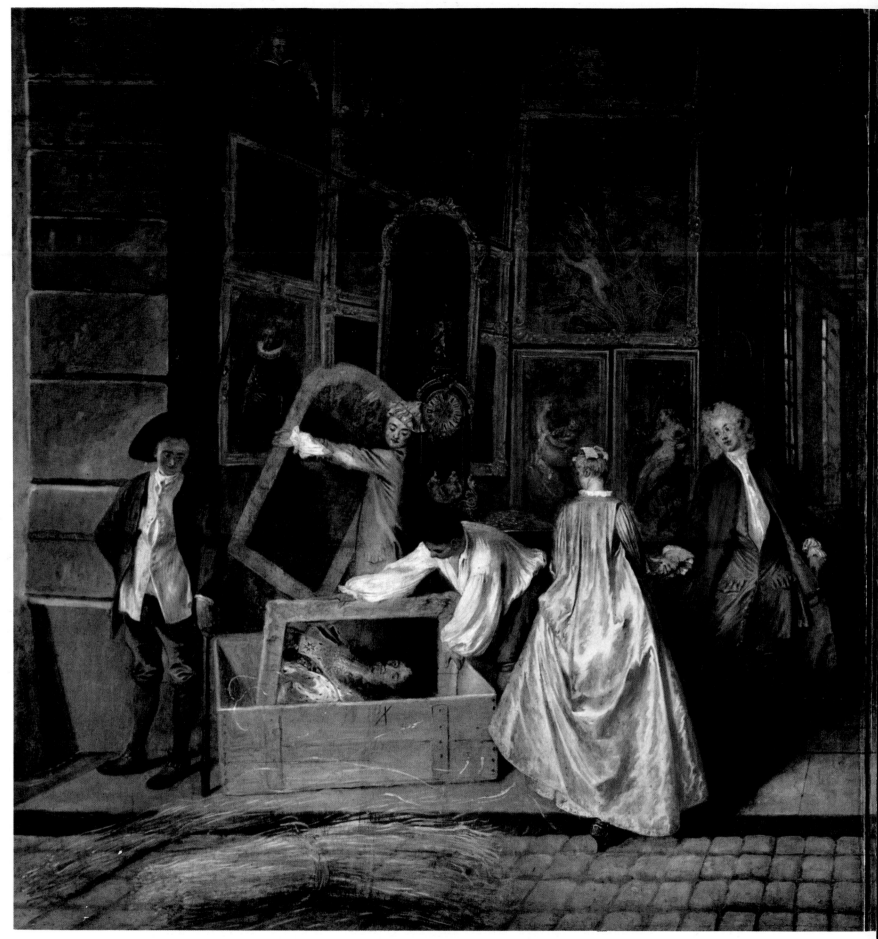

norm, which would then lead to court patronage and the possibility of making a reasonable living. It is not possible to find an artist of either success or talent outside this charmed circle of the court. State patronage had actually destroyed the very thing it sought to cultivate. In a wider European context it has to be remembered that the last thirty years of the seventeenth century was a relatively barren period. In Italy most of the churches had already been decorated, in the Dutch Republic most bourgeois houses were full of paintings, and Louis XIV's extensive palaces were also full. It was not a period of massive economic expansion but of constant war in Europe.

Louis XIV was determined to expand the French frontier northwards at the expense of Flanders, then in Austrian

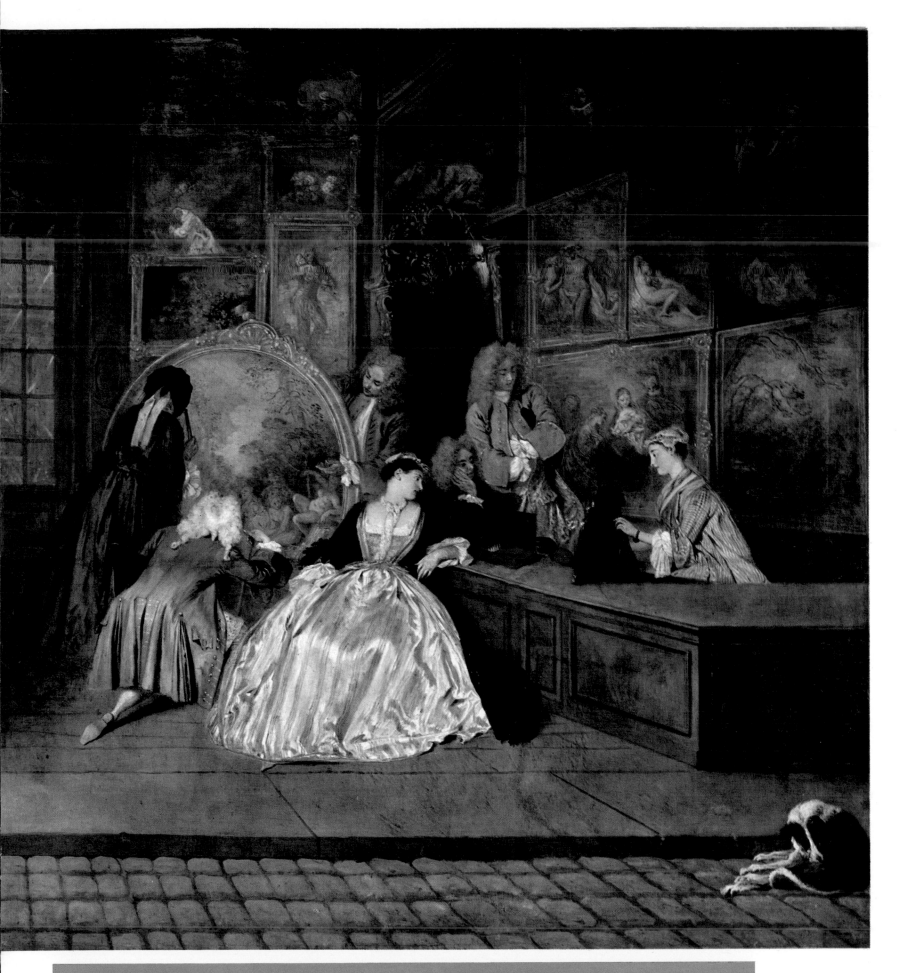

Watteau: *The Sign of Gersaint*, 163 × 308cm, 1720

This brilliant painting is especially interesting because it proves that Watteau was fully conscious of the changes in style and mood he was bringing about. A portrait of Louis XIV is being put away. Thus Watteau is making a joke about the undeniable gloom of the previous fifty years. The picture is a deliberate reaction against the formality of the recent past and is totally light-hearted in feeling. This sense of fun was to reappear in a slightly different and more erotically oriented form in the next generation with Fragonard.

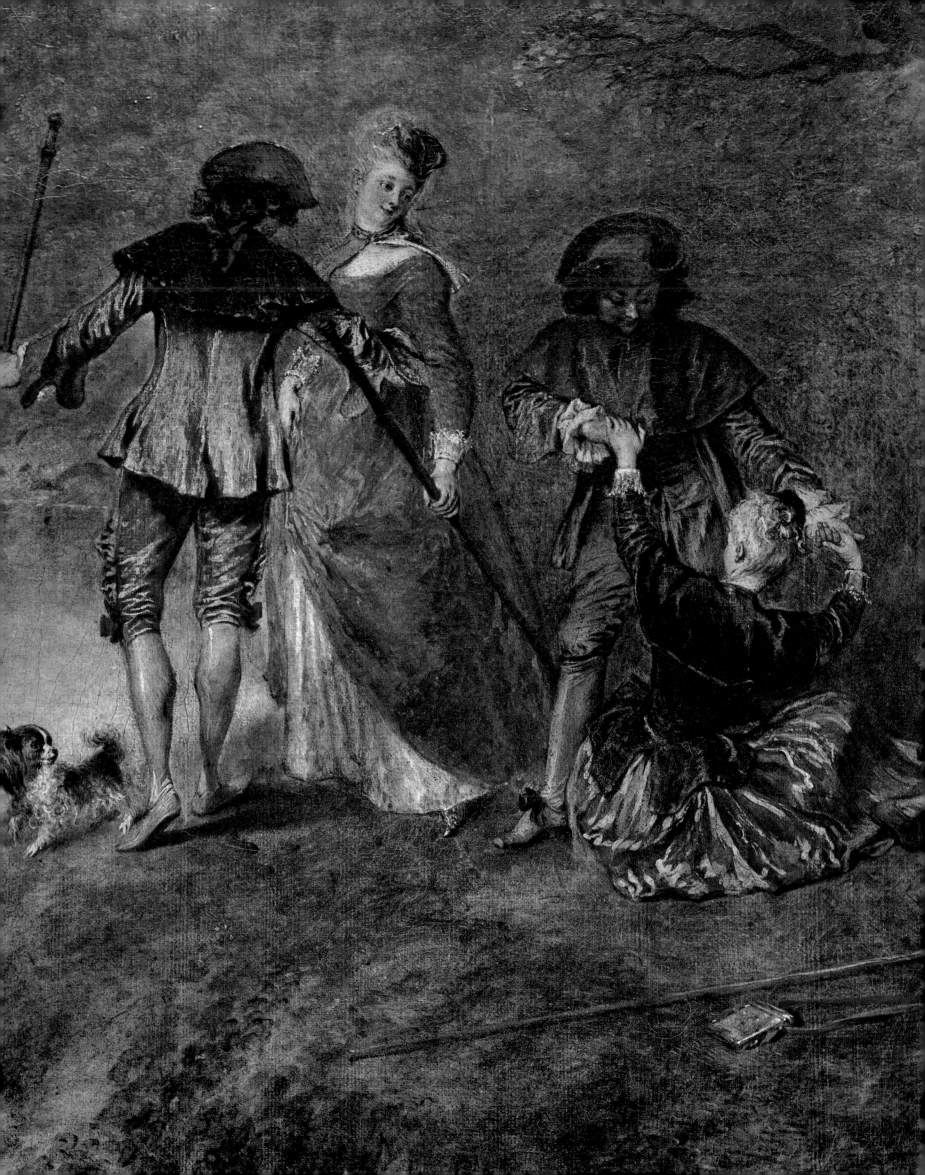

Watteau: *The Embarkation for Cythera*, 128 × 193cm, and detail, 1717

Until Watteau's time imagination had not been allowed to play an important part in the character of French painters. Instead, so many of them had struggled to record the world around them as they saw it, or, like Poussin, they had tried to produce strictly ordered visions of an ideal world. Watteau instituted a profound change. His sitters are observed from life but inhabit a world based on the imagination. In this justly celebrated picture the happy groups of people are shown embarking for the mythical island of Cythera, a place devoted to pure pleasure. Watteau succeeded in this masterpiece in introducing a new lyricism into painting and set the mood for much of the rest of the century.

changes had quietly taken place, but it was only after his death in 1715 that these became obvious. The new monarch inherited, almost by accident, a vastly increased political power and social influence. Louis had brought the aristocracy into his orbit for political reasons and throughout the eighteenth century they remained concentrated on the capital or nearby Versailles.

Thus patronage of painting throughout the eighteenth century, until the Revolution of 1789, also remained nar-

Watteau: *Italian Comedians*, 37 × 48cm. c.1718

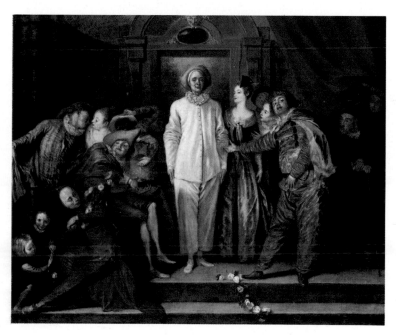

hands, and this constant war drained his own revenues as well as creating a period of instability in the Austrian Netherlands and the Dutch Republic. Recent French and Belgian scholarship has done much to establish the importance of this period, which has been unjustly neglected by previous historians. This is right in the name of history, but it is still difficult to place most of the painters of Louis XIV's reign on the aesthetic level of those who came before and after.

During the Sun King's long reign many social and political

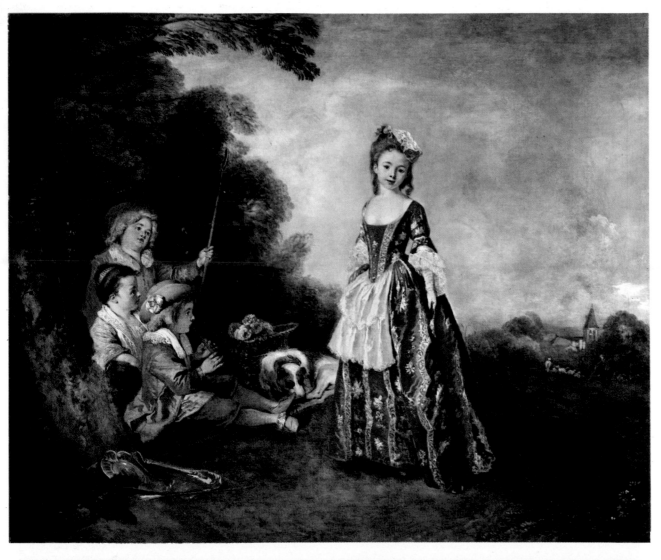

Watteau: *The Dance*.
97 × 107cm. 1719?

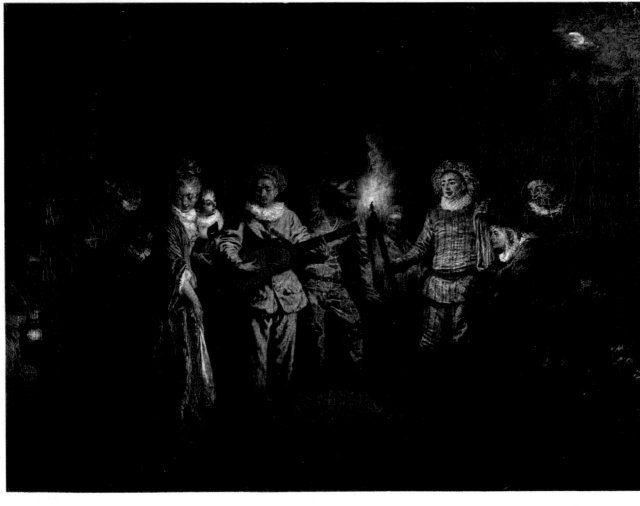

OPPOSITE **Watteau**: *Gilles*.
184 × 149cm, c.1717–19?

Watteau: *Love in the Italian
Theatre*, 37 × 48cm, early
18th century

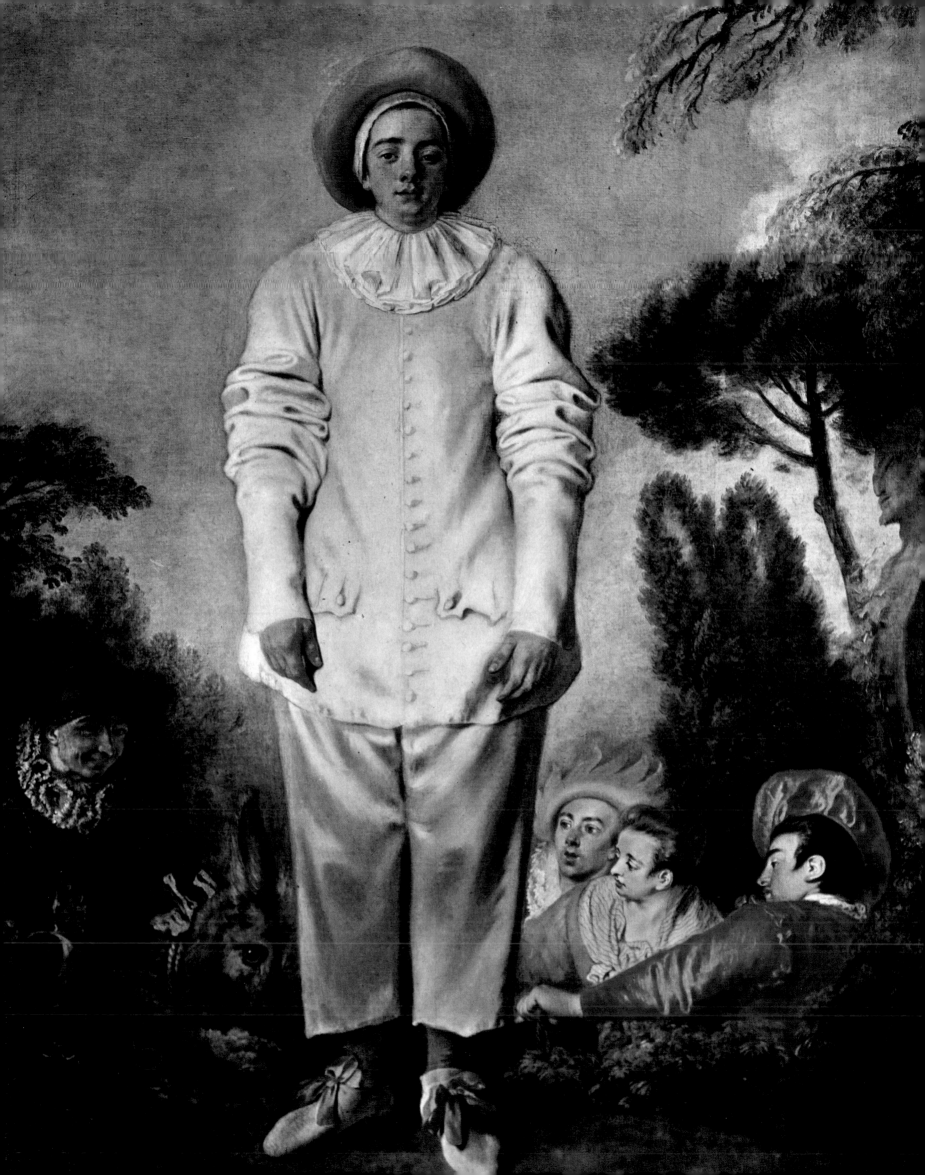

rowly concentrated on the centre. These few patrons were well served by a few painters of genius and a great number of outstanding talent. Because Watteau was an innovator he is too often seen in total isolation and is usually taken to mark a convenient opening to the new period. Born in the far north, at Valenciennes, a town only recently incorporated into France, his few surviving early pictures correspond to the Flemish tradition of small cabinet pictures: genre subject matter with light and delicate colours. Like Poussin before him, Watteau exerted a profound influence after his death. Most of his real achievement was misunderstood by his successors, and only the decorative vocabulary of elegant

couples in ideal landscape settings survived in the work of Lancret and Pater. These two followers of Watteau satisfied the demand for small, brilliantly executed cabinet pictures, which were hung along with Dutch seventeenth-century cabinet pictures, especially those of Dujardin and Berchem.

As the inventor of the genre of elegant company Watteau has perhaps been subjected to too much analysis. The late nineteenth century invented a non-existent melancholy in his art, seeing in his pictures the sadness of a pleasure-seeking aristocracy doomed to destruction through its own frivolity. Watteau's contemporaries certainly did not see him in this light. What he achieved was a perfect image of

Watteau: *The Scale of Love*, 51 × 60cm, 1717?

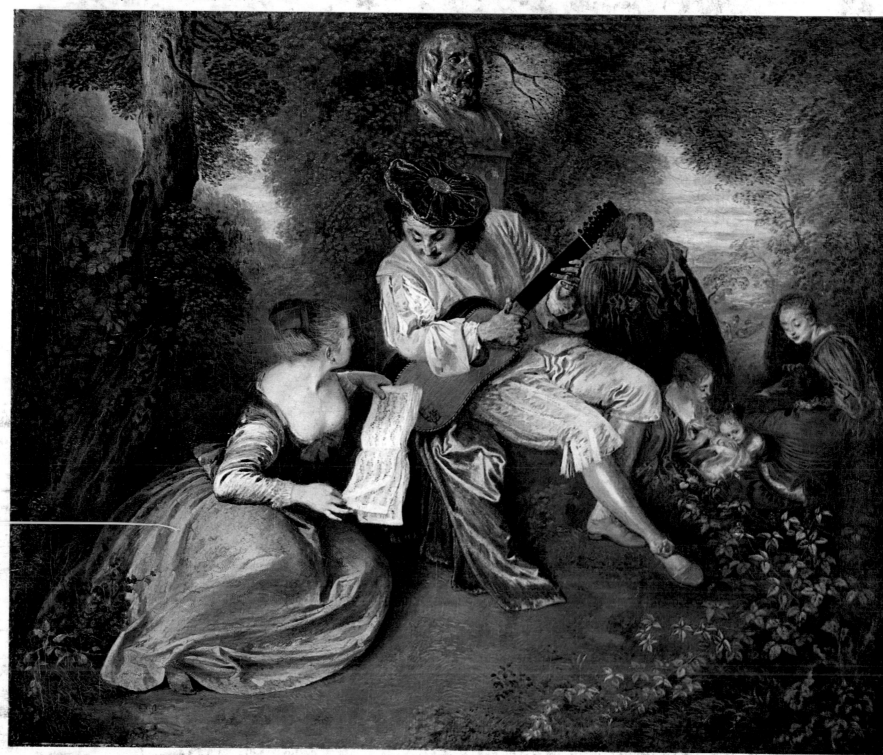

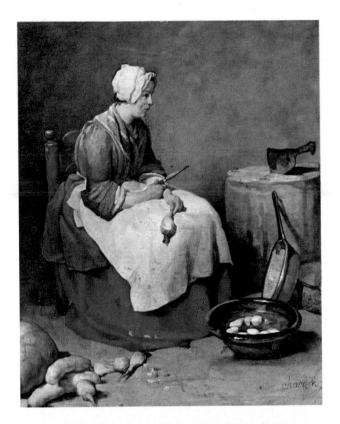

Arcadia. His people are not real in the sense that they can be identified as the marquise of this or the comte of that. Always elegant, always painting with a delicate skill, Watteau was one of the very few painters in the whole history of art who succeeded in turning pretty people doing inconsequential things into a great work of art. Many of his pictures have unfortunately suffered from the use of too much oil, which allowed him to achieve an almost melting technique. The English painter John Constable, when chiding the Royal Academician C. R. Leslie for not being able to copy faithfully Watteau's *Plaisirs du Bal*, noted that the original, but not Leslie's copy, was 'as if painted with honey'.

On a superficial level, once Watteau had set the general mood, the eighteenth century can be seen as having a certain unity. However, a surprising variety of styles existed, and considerable variety of subject matter found favour, in spite of the influence of the Salon and the Academy. It could be argued that, as in the seventeenth century, some of the very best painters stood on the edge of, or even outside, the artistic 'establishment'.

Jean-Baptiste-Siméon Chardin can lay claim to having

LEFT **Chardin**: *A Woman Peeling Turnips*, 46 × 37cm, c.1740

BELOW **Chardin**: *Lady Taking Tea*, 80 × 99cm, 1736

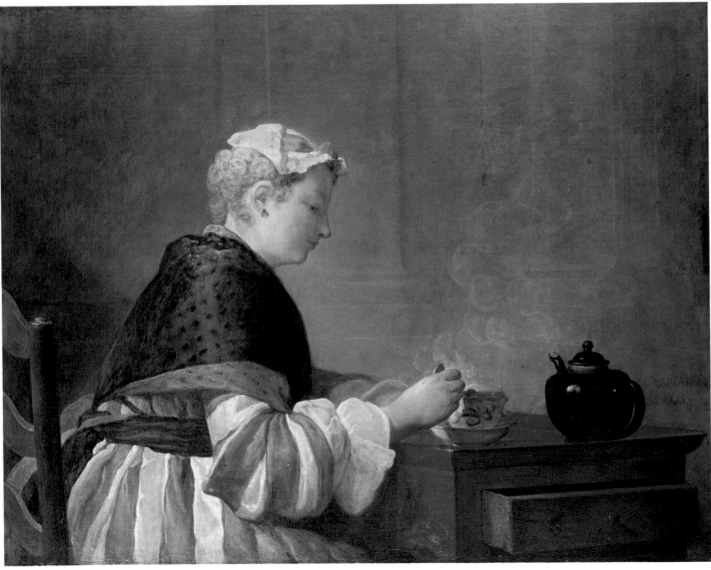

OPPOSITE **Chardin**: *The Young Draughtsman*, 81 × 64cm, 1738

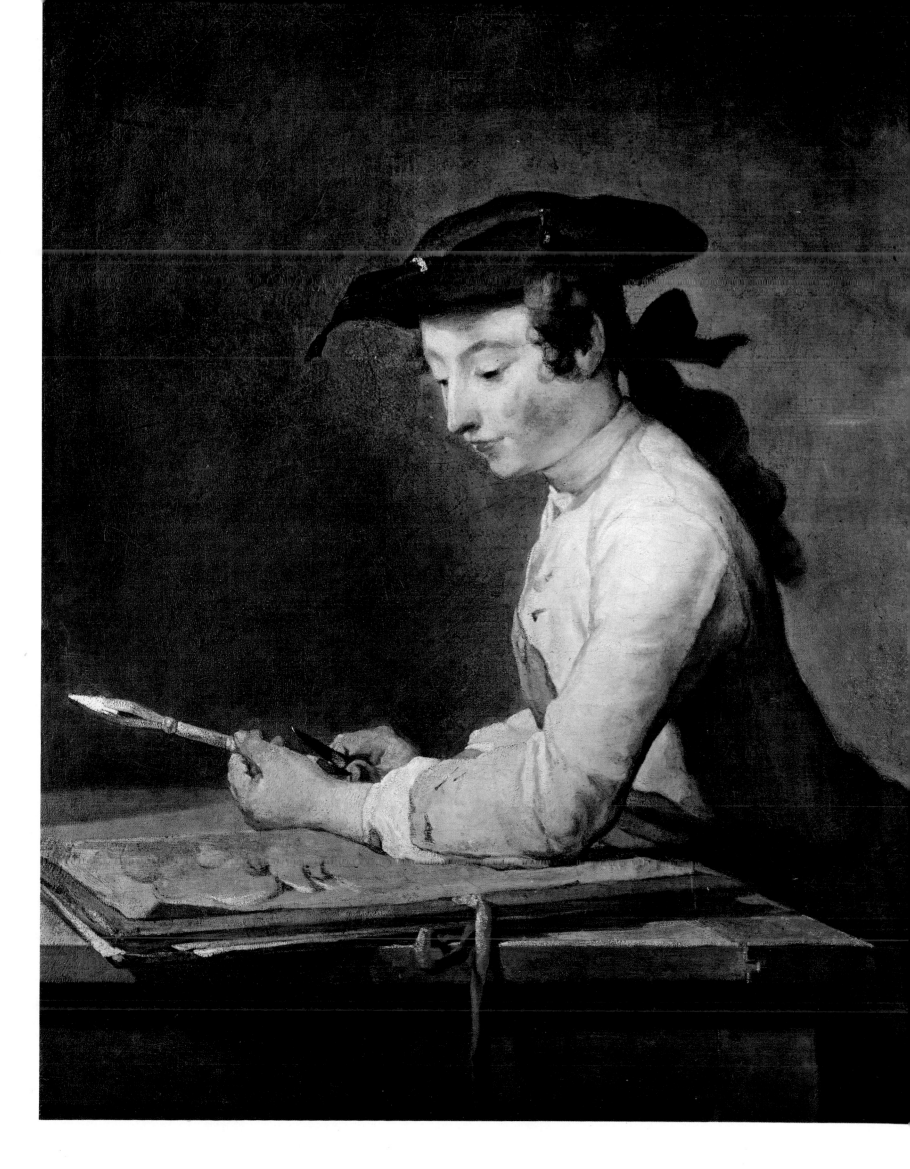

Opposite **Chardin:** *The Draughtsman*, 19 × 17cm, before 1738

In producing this simple but unforgettable picture of the back of a young mean learning to draw, Chardin was continuing the Netherlandish tradition for such types. However, he always observed his figures with a loving concern for their surface characteristics. The surface of his pictures is unique in the whole history of art. He manipulated the oil paint in a very personal way, giving it an almost cheese-like quality. He also modulated his colours extremely subtly without ever letting them become dead and grey. He was also very skilled in the use of the medium of pastel.

RIGHT **Chardin:** *Auguste-Gabriel Godefroy*, 67 × 73cm, early 18th century

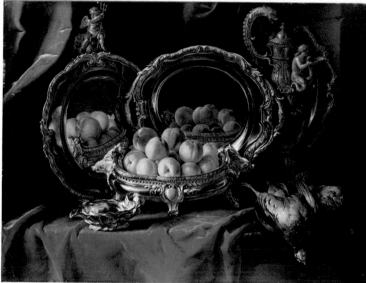

Left **Desportes:** *A Dish of Peaches*, 91 × 118cm, early 18th century

Desportes had learned how to paint opulence from the Dutch painters of the previous century, especially from Abraham van Beyeren. He brought the Dutch banquet scenes up to date. He also excelled in the painting of dead game, an art derived from Jan Fyt and Frans Snyders in Antwerp. The peaches in the dish are especially cleverly depicted, and Desportes favoured peaches and grapes since they afforded an excellent opportunity to depict the bloom on the fruit.

been one of the greatest *painters* that France has produced, simply in terms of his pre-occupation with surface and texture. Imagination formed little or no part of his art, which was confined mostly to still-life, apart from a few genre scenes and portraits. He observed the surface of things with unerring accuracy. Thus his genre scenes, almost by accident, express everything about the outward appearance of kitchenmaids, or better-off ladies taking tea. In his still-life pictures he was equally fastidious, and the textures of onions, dead fish, pitchers, plant pots or just a white tablecloth are depicted with fidelity and sensitivity. It is this very modesty of his art that has led to his being left out of the traditional approach to the philosophy of French painting. Chardin does not belong to the line of sensuality that can be drawn from Watteau through Fragonard and on to Delacroix. Also he does not have the slightest classical overtones, which are the other great thread in the early nineteenth century, with the art of David and Ingres.

In fact, humble still-life painting played an important part

RIGHT **Chardin:** *Still Life with a Turkey*, 96 × 123cm, early 18th century

Oudry: *Basset Hound and Dead Game*, 135 × 109cm, 1740

The relative isolation of each object, crisply defined in light and shade, is typical of Oudry's sharp style developed in the middle years of the century. The influence of Netherlandish painting of the previous century is very strong especially in the way the game is painted. But in contrast to his Dutch and Flemish predecessors Oudry updates the picture by a much more careful use of light, and by the use of paler, subtler, colour, more in keeping with the inlaid furniture, porcelain and tapestries in whose company such a picture would have been seen.

BELOW **Boucher:** *Diana Leaving the Bath*, 57 × 73cm, 1740

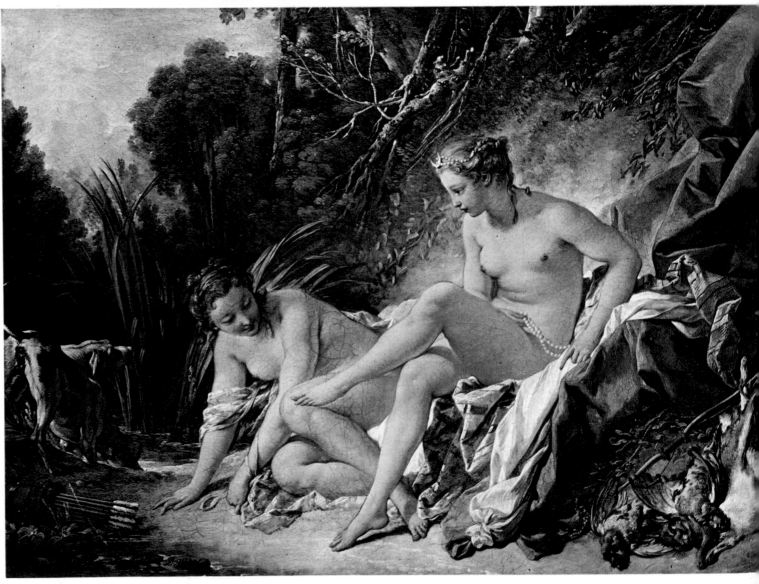

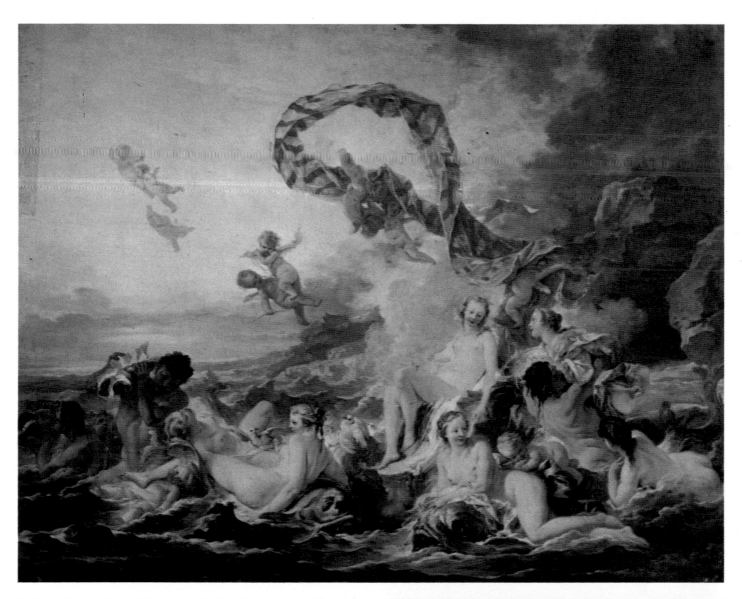

in French painting of this period. Dutch pictures of the previous century were avidly collected by the aristocrats and made enormous prices in the sale rooms. The earliest of the great still-life painters was Desportes, who began his career under Louis XIV and was able to achieve for still-life what Rigaud had managed for portraiture. Formal and sensuous at the same time, Desportes could satisfy his patrons because he recorded the surface glitter of things, such as the bloom on the peach. Of a slightly later generation, Jean-Baptiste Oudry was even more obsessed with surface. His style of painting was even harder, using bright cool colour, and all his subjects have a certain angularity.

The intention behind this type of painting was to achieve an ideal decoration. The role of painting for the aristocracy was totally decorative in the best sense of the word. Large reception rooms and intimate apartments were covered with many different forms of attractive decorations, painted panelling, tapestries and pictures. Thus almost all the successful painters of this period lack many attributes common to other schools and periods of painting. This has led to a good deal of misunderstanding. Many writers of art-history, brought up on the formal order of a Piero della Francesca, or nourished with the intellectual ideas of Poussin, find themselves at a loss with the two great decorative painters of the period – Boucher and Fragonard.

Boucher: *The Triumph of Venus*, 130 × 162cm, and detail (pages 48–9), 1740

This complex picture has affinities with both Raphael's *Triumph of Galatea* in the Farnesina, Rome, and Poussin's *Triumph of Venus*. Boucher has used his two formal and serious prototypes for a totally frivolous result. The gravity of his predecessors did not interfere with his intention of being gay and jolly. The picture is an interesting testimony to Boucher's international success in his lifetime since it was bought by Tessin, the Swedish ambassador, and taken to Stockholm, where it has remained ever since.

Boucher, the older of the two, went to Rome as a young man, and then returned to Paris to work as a brilliantly successful court painter throughout the middle years of the eighteenth century. Unfortunately for his subsequent reputation, he evolved an easily recognizable decorative formula – basically pink figures and baby blue everything else. The ground, the trees and the sky would be painted with the same blue in order to achieve a decorative harmony. The

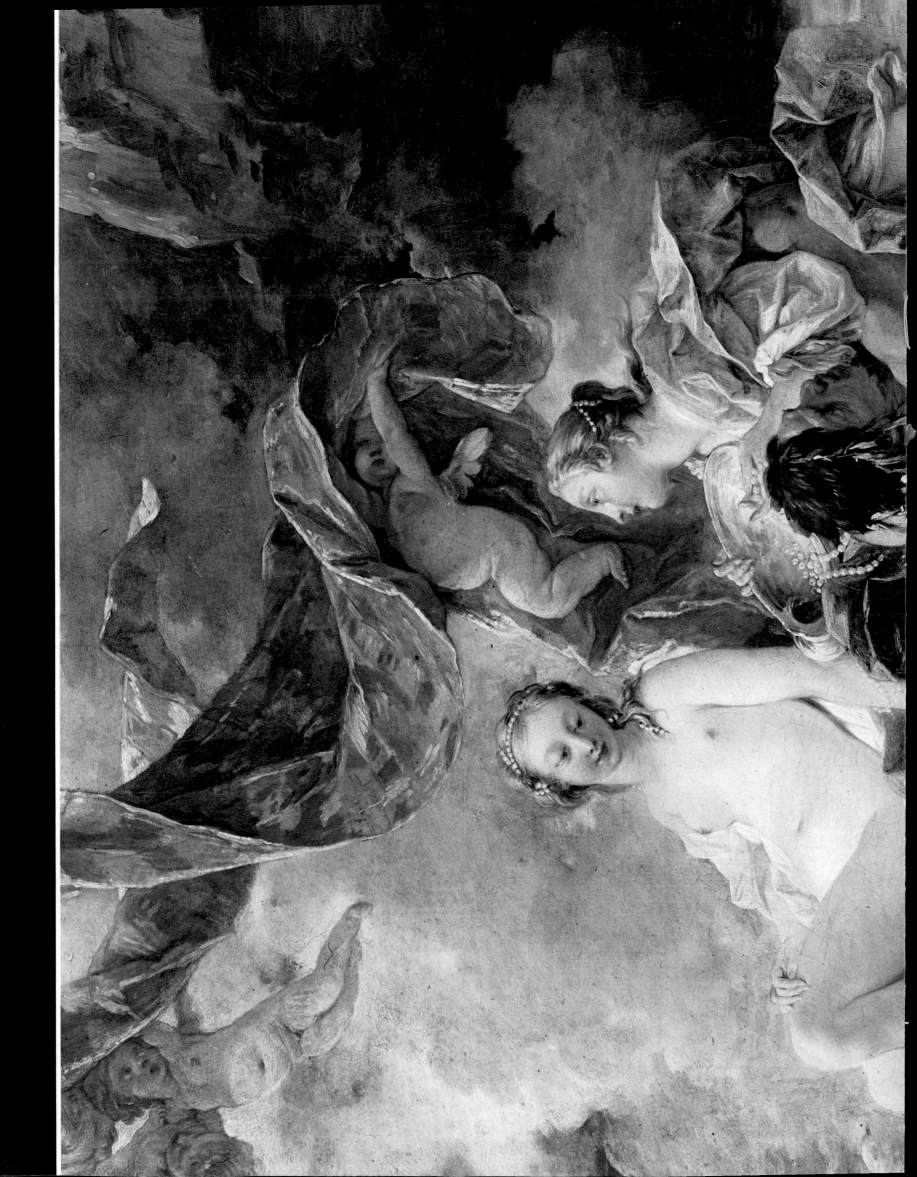

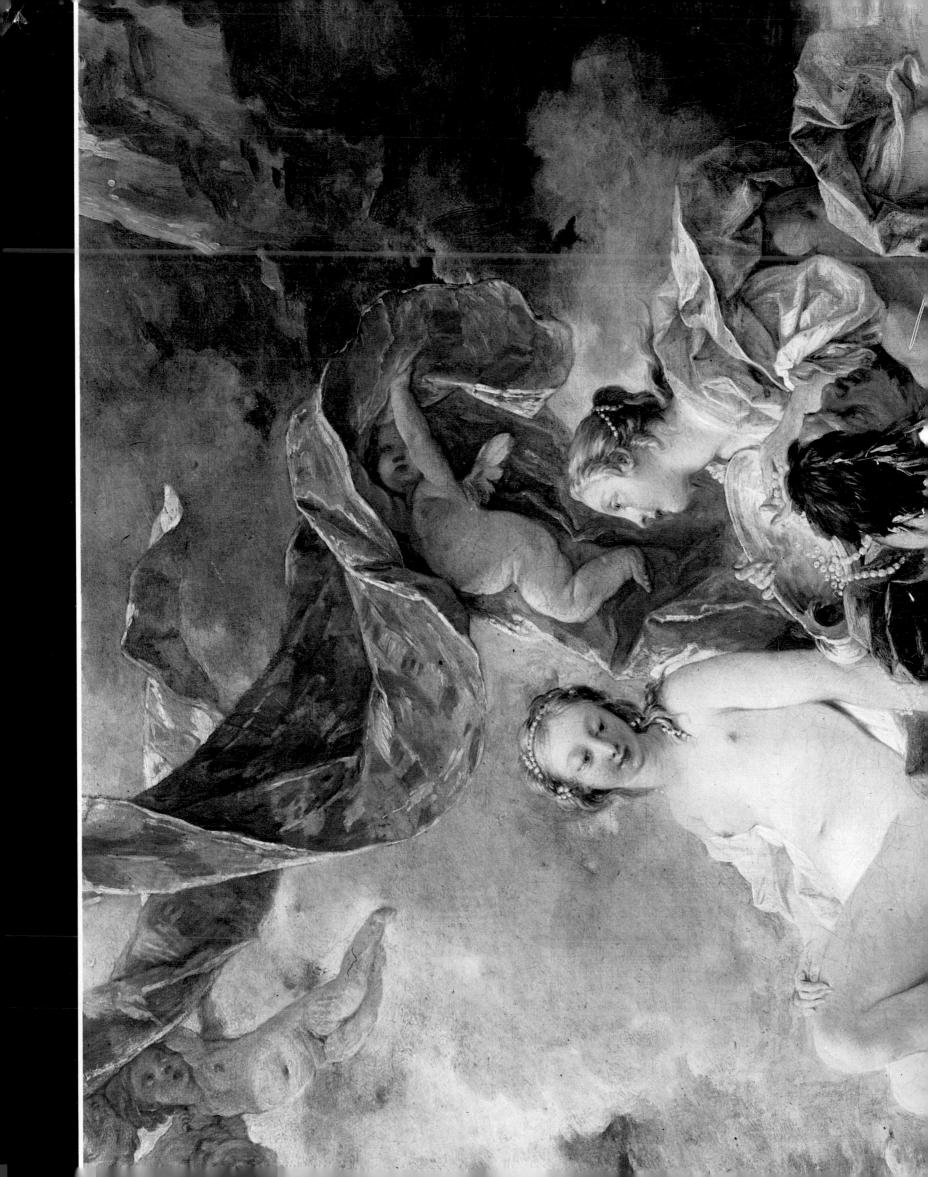

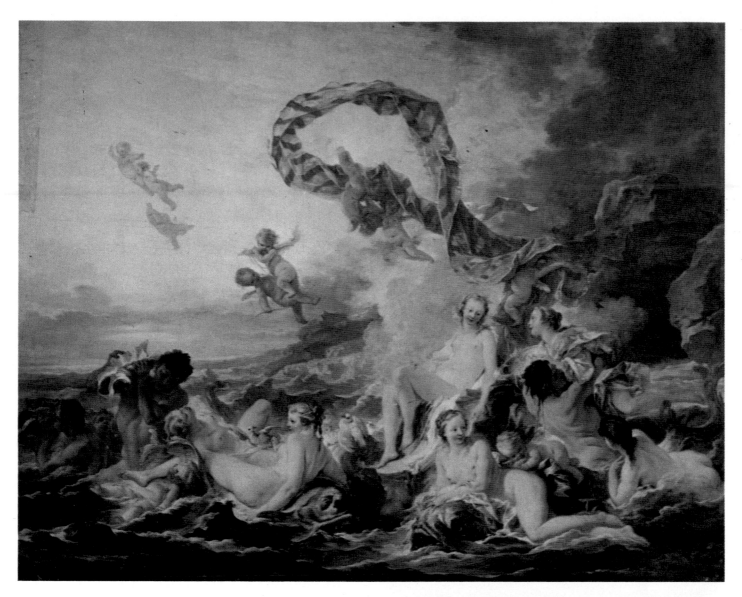

in French painting of this period. Dutch pictures of the previous century were avidly collected by the aristocrats and made enormous prices in the sale rooms. The earliest of the great still-life painters was Desportes, who began his career under Louis XIV and was able to achieve for still-life what Rigaud had managed for portraiture. Formal and sensuous at the same time, Desportes could satisfy his patrons because he recorded the surface glitter of things, such as the bloom on the peach. Of a slightly later generation, Jean-Baptiste Oudry was even more obsessed with surface. His style of painting was even harder, using bright cool colour, and all his subjects have a certain angularity.

The intention behind this type of painting was to achieve an ideal decoration. The role of painting for the aristocracy was totally decorative in the best sense of the word. Large reception rooms and intimate apartments were covered with many different forms of attractive decorations, painted panelling, tapestries and pictures. Thus almost all the successful painters of this period lack many attributes common to other schools and periods of painting. This has led to a good deal of misunderstanding. Many writers of art-history, brought up on the formal order of a Piero della Francesca, or nourished with the intellectual ideas of Poussin, find themselves at a loss with the two great decorative painters of the period — Boucher and Fragonard.

Boucher: *The Triumph of Venus*, 130 × 162cm, and detail (pages 48–9), 1740

This complex picture has affinities with both Raphael's *Triumph of Galatea* in the Farnesina, Rome, and Poussin's *Triumph of Venus*. Boucher has used his two formal and serious prototypes for a totally frivolous result. The gravity of his predecessors did not interfere with his intention of being gay and jolly. The picture is an interesting testimony to Boucher's international success in his lifetime since it was bought by Tessin, the Swedish ambassador, and taken to Stockholm, where it has remained ever since.

Boucher, the older of the two, went to Rome as a young man, and then returned to Paris to work as a brilliantly successful court painter throughout the middle years of the eighteenth century. Unfortunately for his subsequent reputation, he evolved an easily recognizable decorative formula — basically pink figures and baby blue everything else. The ground, the trees and the sky would be painted with the same blue in order to achieve a decorative harmony. The

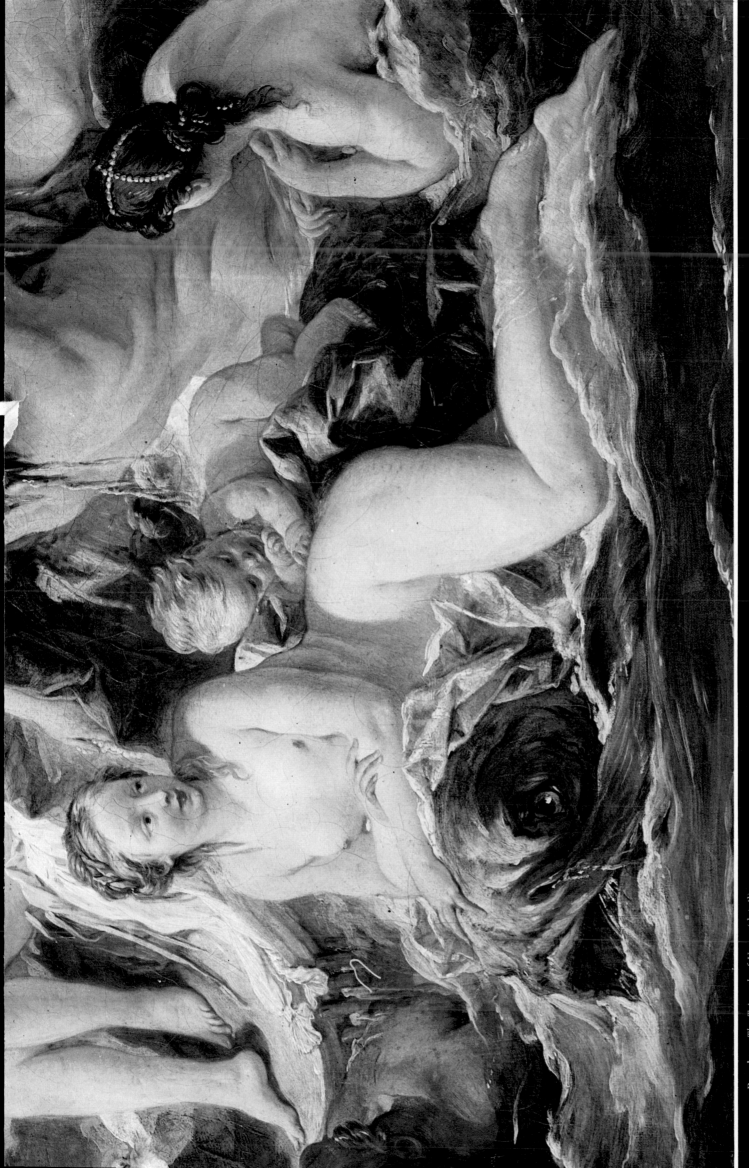

Boucher: *The Triumph of Venus* (detail)

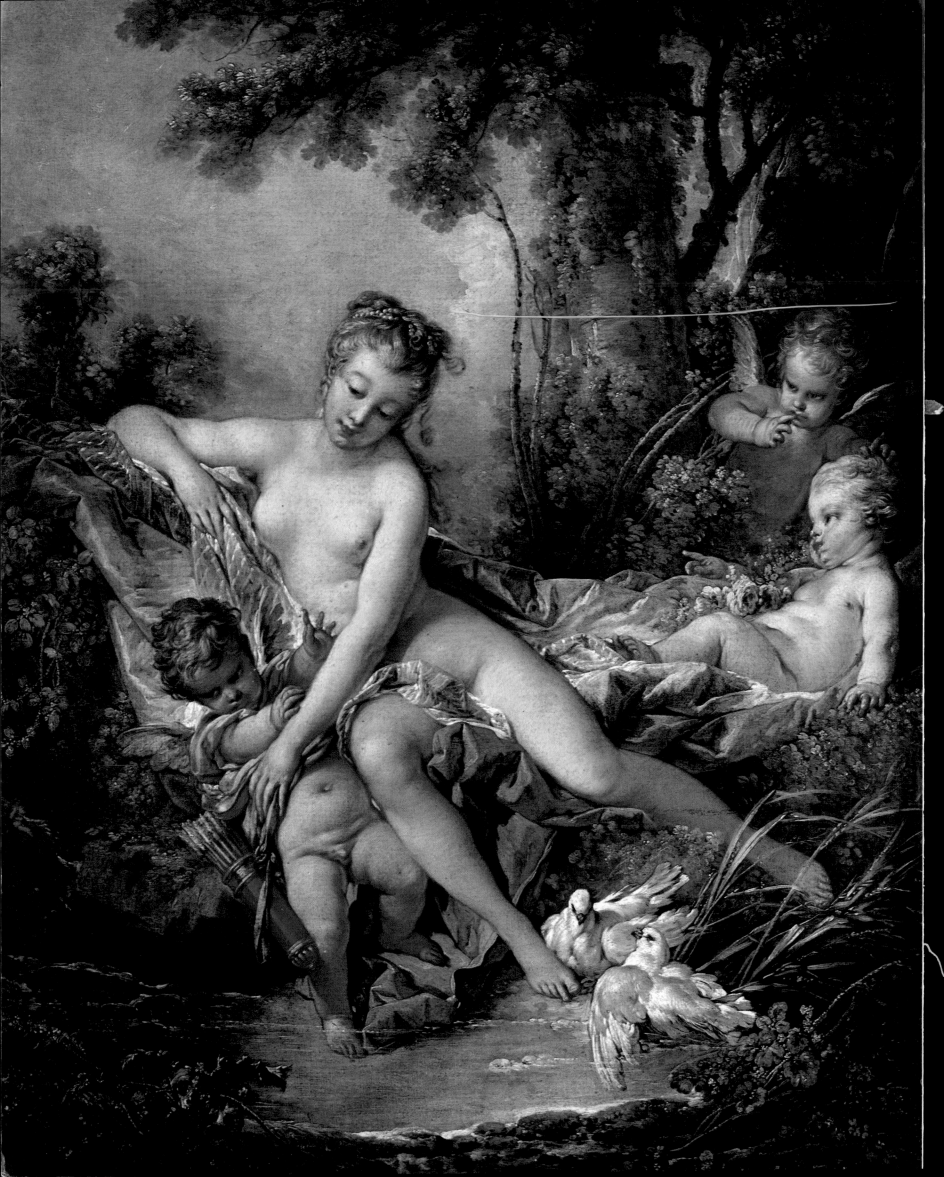

result, now so often seen on the bare walls of a picture gallery, was the expression of enormous skill matched with a sense of humour. Perhaps it is this sense of fun, which characterizes even more Boucher's pupil, Fragonard, that has been the cause of such disapprobation at the hands of later critics, especially those in the English-speaking world. Both Boucher and Fragonard pandered to the tastes of a dissolute aris-

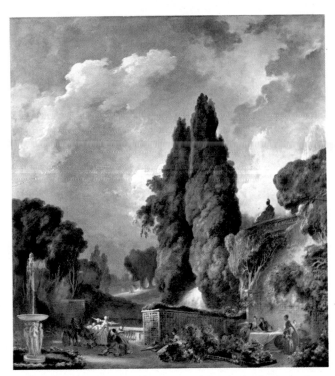

Fragonard: *Blindman's Bluff*, 216 × 197cm, 1770s

Fragonard: *The Bathers*, 64 × 80cm, and detail (pages 52–3), late 1760s

Fragonard's debt to Boucher is very strong in this picture as there is a very strong sensuality in the poses of the nudes. Fragonard was, however, more subtle than Boucher, especially in the handling of the paint. Boucher, particularly in his portraits, was able to use sound and sober craftsmanship, quite in keeping with the Renaissance tradition. Fragonard, on the other hand, like Watteau, mixed a large quantity of oil with his paint and applied it with long flowing strokes. These rapid strokes of the brush give much of his work an appearance of spontaneity. In fact, it was as carefully controlled as the brushwork of Rembrandt, in the previous century.

OPPOSITE **Boucher:** *Venus Consoling Love*, 107 × 85cm, 1751

51

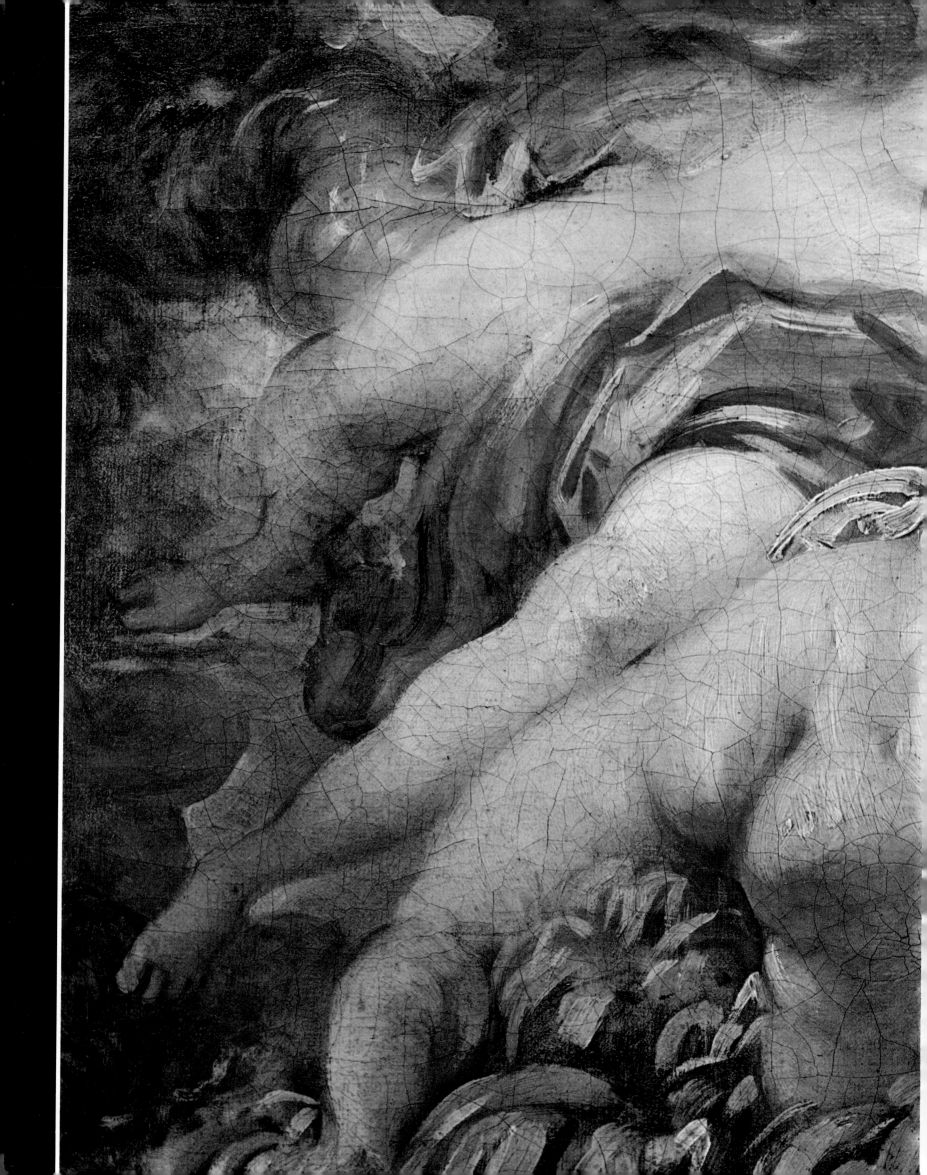

tocracy. Thus moral and political complaints can be laid against them. Fragonard in particular, apart from his many other qualities, well understood a rude joke. He introduced all manner of innuendo, like the gallant in a direct line of view with the lady's underwear in *The Swing*, in the Wallace Collection, London. He could also paint scenes of outright sexual intimacy and still carry them off as a work of art.

Fragonard had learned from Boucher an enormous facility

Greuze: *G. Gougenot de Croissy*, 81 × 64cm, 1756

Portraiture played a relatively limited role in eighteenth-century France, where it tended to be the preserve of specialists who produced much of their best work in the medium of pastel. Boucher, Fragonard, and Greuze all painted a few portraits, and in each instance their undoubted abilities in this field should be enough to silence the critics of their more frivolous productions. Much of Greuze's art is so frankly sentimental that it comes as a refreshing surprise to see his ability to record with sensitivity the features of a sitter who happened also to be a friend. The brilliant painting of the velvet coat and lace is easily taken for granted too.

BELOW **Greuze:** *The Father's Curse*, 130 × 162cm, c.1767

Duplessis: *Glück at the Clavichord*, 99·5 × 80·5cm, 1775

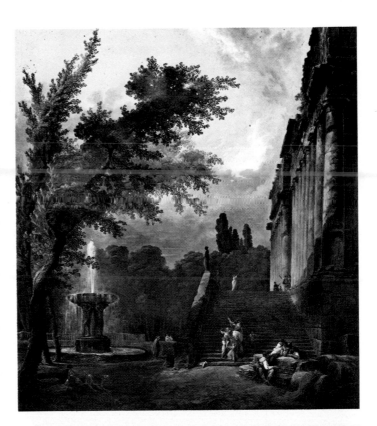

Above **Hubert Robert:** *Fountains and Colonnades in a Park*, 244 × 216cm, 1775

At first sight this picture seems to epitomize the luxury-loving elegant and intellectually superficial tastes of the French aristocracy in the years immediately preceding the Revolution. Yet this decorative picture painted only fourteen years before the Revolution already shows a new interest in classical antiquity. The grand ruins on the right are just beginning to lose their picturesque quality in exchange for a much more archeological approach. Late in life Hubert Robert was to record in several of his pictures the demolitions of important buildings in or near Paris. He made many drawings of classical ruins during his years in Italy, and a whole group of these is preserved in the museum of Valence.

with the brush and combined it with a much wider curiosity and appreciation of the old masters. He was thus able to paint in many different styles. Perhaps his greatest achievement was the decoration of a room for Mme du Barry in the 1770s, now in the Frick Collection, New York. As one eminent critic quietly remarked, 'Even the most hardened Renaissance expert *melts* in that room.' But Fragonard's room was rejected by his patron and was immediately replaced by a scheme with neo-classical overtones painted by Vien. Thus there was already a sign of a great change in taste well before the Revolution began in 1789.

The Revolution speeded up the process of change by allowing a new generation of painters to gain important patronage rather earlier in their careers than would otherwise have been possible. But the last years of the old monarchy were remarkably active, and are characterized by a mixing of the old and new styles by different generations of painters. One of the most important painters of the period was Jean-Baptiste Greuze. Most of his pictures were painted with moral intent. He favoured dying fathers with dissolute sons at their feet, too late repentant. His other forte was the single bust of a simpering girl. Popular in his time, Greuze achieved even greater posthumous success. He was, however, a serious painter of talent, yet even today his art is difficult to contemplate fairly. As a portraitist he was brilliant and was well able to assess character.

Greuze appealed essentially to a bourgeois taste. His moralizings, however gentle, were not aristocratic in their appeal. In these last years of the *ancien régime* the spectrum

RIGHT **Drouais:** *The Duc de Berri and the Compte de Provence as Children*, 95 × 127cm, early 18th century

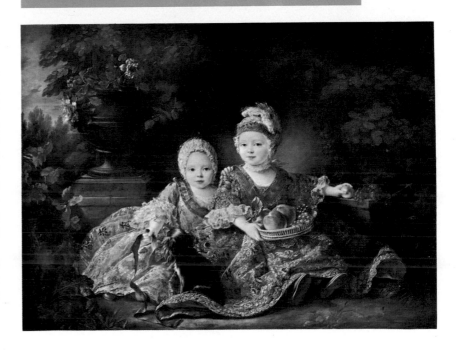

Liotard: *View of Geneva from the Artist's Studio*, 45 × 58cm, 18th century

Liotard: *Mlle Lavergne*, 54 × 42cm, 1746

of what was permitted was slowly broadening. Jacques-Louis David painted his *Oath of the Horatii*, in the Louvre, in 1785, four years before the start of the Revolution. This austere picture is often illustrated as epitomizing the revolutionary ideals of honour and the desire to return to a Republic based on classical antiquity.

David's career is unique in the history of French art for several reasons. He was active right through the period of the Revolution and the rule of Napoleon. His principles would not allow him to work under the restored Bourbon monarchy in 1815, so he retired to Brussels and continued to paint in a style that had at last become old-fashioned. Born in 1746, David was already well into middle age by the end of the century, yet he is usually taken to be a key painter of the nineteenth century rather than an innovator in an

Vigée Lebrun: *The Artist and her Daughter*, 190 × 121cm, 1786

This enchanting picture lies half way between the sentiment and frivolity of the middle years of the eighteenth century and the austerity, which was becoming fashionable in the 1780s and which became the only style in favour during the years of the Revolution. Mme Vigée Lebrun was very successful as court painter under Louis XVI, perhaps because she was able to compromise between the two styles and did not, like Fragonard, fail completely to understand the new demands of patrons. Her husband was one of the most active art dealers of his generation and owned Vermeer's *Astronomer*.

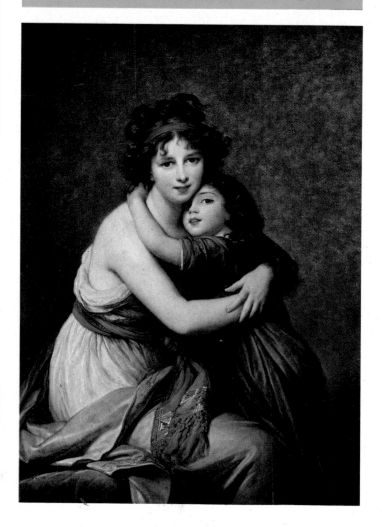

earlier period basically out of keeping with his times. He was utterly serious-minded, abhorred frivolity, and was a passionately energetic teacher. In his early work he genuinely sought to reproduce the austerity and purity of the early Roman Republic. Much of his stylistic inspiration was based on an updating of Poussin, and it was from Poussin that he inherited his frozen poses and carefully modulated colours. David intensified himself culturally with the Revolution. By contrast, both Greuze and Fragonard lived on, destitute and unable to work. David's energy meant that he created a new type of art — the political picture destined to set the Revolutionary ideals on an exalted level. *Marat Assassinated in his Bath* becomes a quasi-religious image — it has been com-

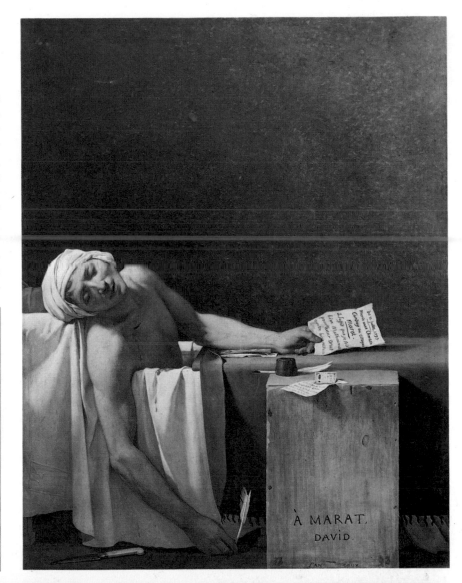

David: *Marat Assassinated*, 165 × 128cm, and detail, 1793

The assassination of Marat, one of the leading Revolutionary figures, while in his bath, by Charlotte Corday, was one of the most sensational events of that turbulent time. For all his faults, Marat stood in the eyes of his Revolutionary contemporaries for a bravery and austerity emulating the ancient Greeks and Rome in the days of the Republic. David sought to epitomize these qualities in this formal, *Pietà*-like picture — a scene of Republican martyrdom. It is known that Marat suffered from a disease that caused him to take frequent baths, and David's characteristic self-discipline has caused him to simplify dramatically the scene of a man dead in his bath in order to accent the pathos of the event.

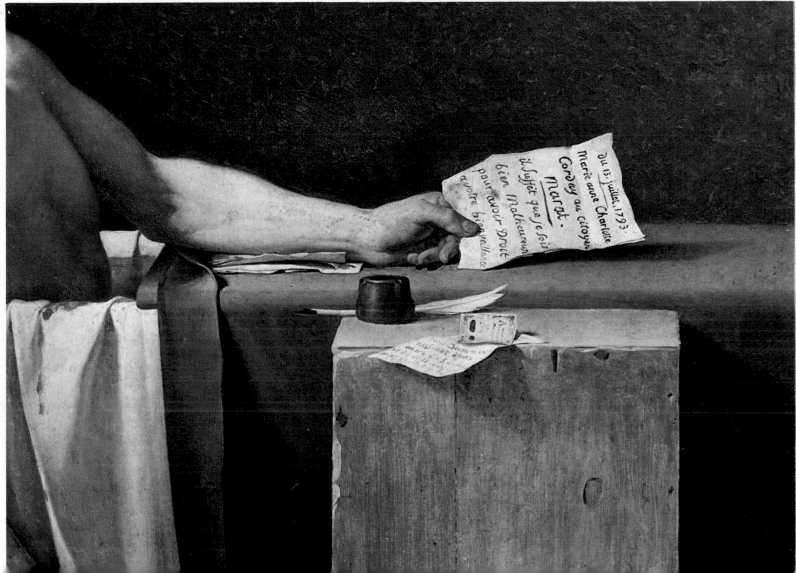

pared with a conventional *Pietà* in which everything is concentrated on the one emotion, and every scrap of unnecessary detail is omitted — a principle of which Poussin would have heartily approved.

Following his association with the Revolution, David, quite astonishingly, was able to identify himself with the regime of Napoleon. In exactly the way he treated the Revolution, so he treated Napoleon. In essence his style did not really change, but what he recorded did. He deified Napoleon as he had deified Marat dead in his bath. Napoleon's self-made empire was recorded with a brilliant meticulousness, which allows such events as Napoleon's coronation to be studied with that degree of detail only possible for similar events after the invention of the camera. As a portraitist he also came into his own. He observed rather than flattered and imbued his sitters with a feeling of purity.

David was certainly the most important painter of his time, and almost all his contemporaries were in some way influenced by him. In noting the exception it must be remembered that Prud'hon was quite untypical of his time. He lost himself in a misty world inspired by Leonardo da Vinci and Correggio, and combined these influences with a delicate sensibility that makes him one of the best portraitists of the age. All his edges were softened and his colours muted. Yet

David: *The Coronation of Napoleon*, 610 × 951 cm, and detail, 1804

This vast picture — it is thirty-one feet wide — is the greatest monument to David's industry. It is perhaps difficult even now to be entirely serious about the outward trappings of Napoleon's short-lived Empire. David treated the picture as an exercise in the accurate recording of a very solemn event. Napoleon took the crown from the Pope's hands, crowned himself and then crowned Josephine. So meticulous is the picture that almost all the spectators can be identified. The detail reproduced here shows David's sensitivity as a portraitist, even when working on this scale. It is almost as if the artist had a certain sympathy with the kindly old pope, who was effectively Napoleon's prisoner. This is in a complete contrast to David's merciless treatment of Marie Antoinette in his famous drawing of her on her way to execution.

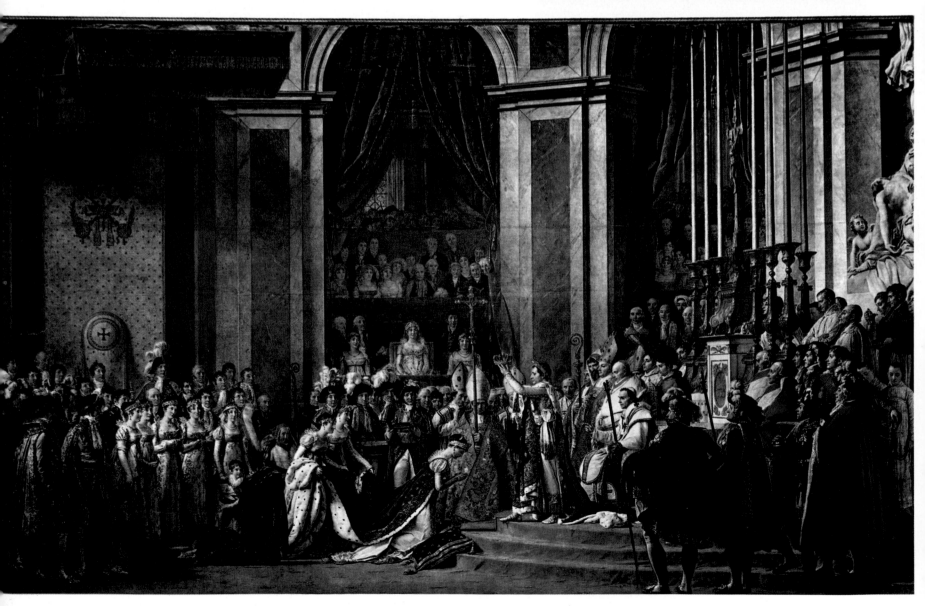

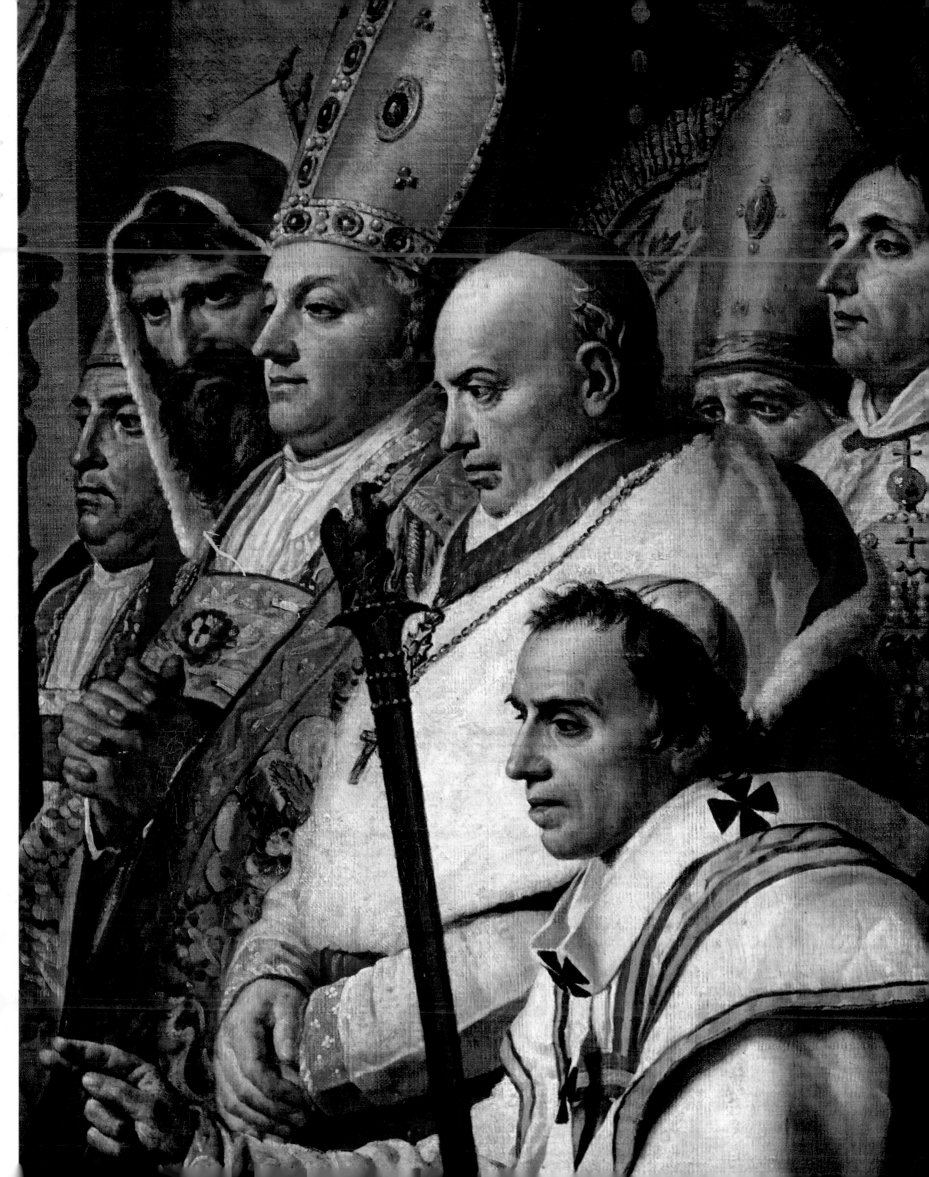

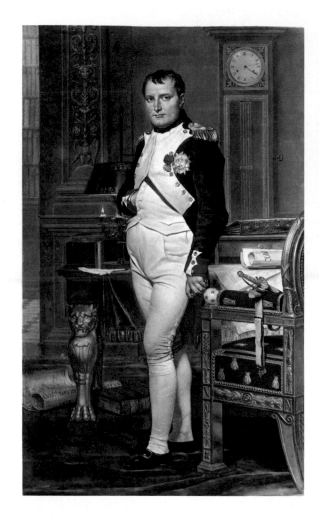

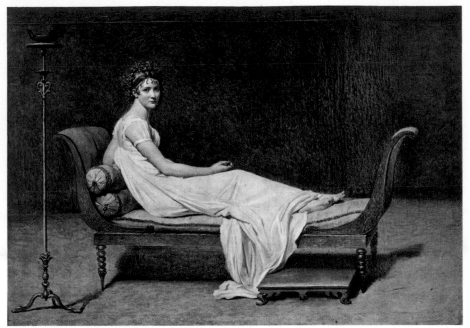

David: *Mme Récamier*, 170 × 240cm, 1800

David: *Napoleon in his Study*, 203·9 × 125·1cm, 1812

his sitters appear quite up to date and in the real world, as in the superb *Schimmelpenninck Family*, in the Rijksmuseum, Amsterdam.

Many of David's pupils were immensely talented like Gros and Girodet, but they completely lacked their master's moral seriousness. Gros concentrated on enormous historical and mythological pictures, and Girodet devoted himself to extravagant imagination. He was snubbed by David for this and the career of Girodet ended in inertia, that of Gros in suicide.

The Restoration of the Bourbon monarchy in 1815 did not

Gros: *Napoleon at the Battle of Eylau*, 533 × 800cm, 1808

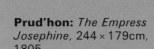

Prud'hon: *The Empress Josephine*, 244 × 179cm, 1805

Even though Prud'hon placed the Empress in a very carefully contrived pose and painted the exposed parts of her body as if they had been sculpted in marble, the neo-classical elements in the picture are strictly limited. Instead, the grandeur of the sitter was reduced to a certain informality by being placed in a park-like setting. Thus the mood is specifically Romantic. This picture is in fact a little unusual for Prud'hon who in so many of his pictures preferred to use much softer edges derived from the art of Correggio and Leonardo, both of whom were represented by supreme works in the Louvre.

have an immediate effect on the artistic scene – the real changes were to become obvious in the 1820s. The period following 1789 had been one of immense upheaval. Almost all the collections of the Old Masters had been sold by the Revolutionary authorities, and the émigrés in the early part of the Revolution had taken much of their property with them on leaving France. Thus, an enormous number of Italian and Dutch pictures left the country at this time. There was a terrible spate of destruction of French painting of the previous two centuries – many were portraits, ranging from the tradition of municipal portraiture (of which there are a few tantalizing survivals in Toulouse and Narbonne) to portraiture of the monarchy and aristocracy. Much of this was summarily consigned to the flames. Religious and mythological pictures fared slightly better, and in the early years of the Revolution a number of provincial centres were set up in order to receive the works of art confiscated from the local convents and churches. These centres became the foundations of the whole system of French provincial museums, which from this date were to contain significant numbers of Old Master paintings. This was to have a very definite effect on the course of painting in France in the nineteenth cen-

tury. It is often forgotten today how in all periods up to the end of the nineteenth century young painters relied on the art of the immediate past for both knowledge and inspiration.

The French royal collection, alone in not being dispersed, became public property. The Louvre became a great picture gallery accessible to the general public. To it was added an enormous number of other great pictures, mostly the contents of the German, Dutch and Italian picture galleries confiscated during the Napoleonic conquests of Europe. Most of these pictures were returned to their respective countries after the Second Peace of Paris in 1815. But this sudden exposure to so much of the art of the past must be a partial explanation for the changes which came over French painting in the 1820s. The period opened conventionally enough with David's most talented pupil, Jean-Auguste-Dominique Ingres. He mastered David's technique, and as a young man painted superb portraits of people from many different walks of life, from Napoleon downwards. He spent much of the first part of his long career in Rome – this had been quite normal for an aspiring academic painter since the time of Poussin. Painters, ambitious for official recognition, travelled to Italy in order to learn the craft of painting at the source and to

Ingres: *Angelica*, 97 × 75cm, 1859

Opposite **Ingres:** *Mademoiselle Rivière*, 100 × 70cm, 1805

Mlle Rivière has lived on as an inscrutable teenager with a certain dignity she may not have possessed in life. When compared with contemporary art Ingres' portraits may appear to contain an element of super-realism since their accurate observation is taken to such an extreme that the result is unreal again. Through his obsession with draughtsmanship Ingres was able to capture a likeness, but Mlle Rivière belongs to an erudite world of the classical antique. Without ever quoting exactly from the Old Masters Ingres succeeded in bringing up to date in nineteenth-century terms the Renaissance ideal of perfection seen in the *Mona Lisa*.

BELOW **Ingres:** *The Source*, 164 × 82cm, 1855

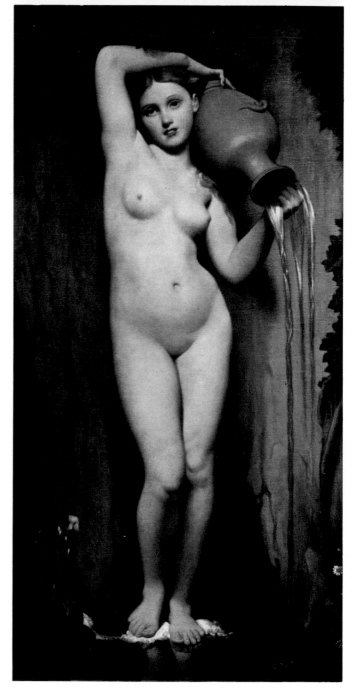

grasp the necessary pictorial conventions they knew would bring them official success. It can be argued of course that almost all the truly great French painters ignored these rules. The Le Nain brothers, Georges de La Tour, Watteau, Chardin, all occasionally show some awareness of Italian conventions, which they never set out either to imitate or to rival.

An example of the effect of the Old Masters on a young painter is seen in the art of the brilliant young Achille Michallon. Barely in his twenties, he produced a short series of erudite versions of Gaspard Poussin's classical landscapes. Gaspard Poussin, the brother-in-law of Nicolas Poussin, had specialized exclusively in neatly ordered landscapes of the Roman Campagna; these had become very popular and were much imitated for a hundred years after his death. The young Delacroix preferred to steep himself in the art of Rubens, being especially responsive to both his brushwork and colour, and preparing himself for one of the most spectacular careers of the nineteenth century. Delacroix's originality has perhaps been over-praised by many writers, and much of his art was frankly derivative from the Old Masters. Predictably Ingres chose to quote from Philippe de Champaigne for his *Vow of Louis XIII* painted for Montauban cathedral.

It could be argued that the greatest pictures of the age were produced by two painters who were very different from

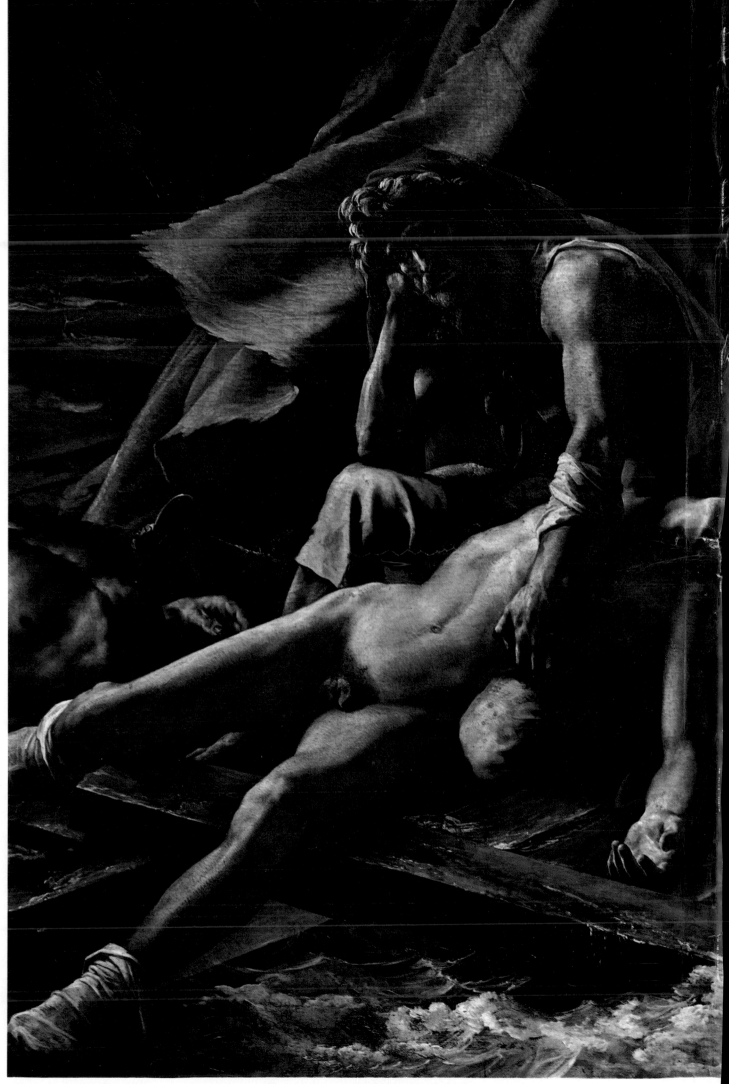

Gericault: *Raft of the Medusa* (detail)

PAGES 66–7. **Gericault:** *Raft of the Medusa*, 491 × 716cm, 1819

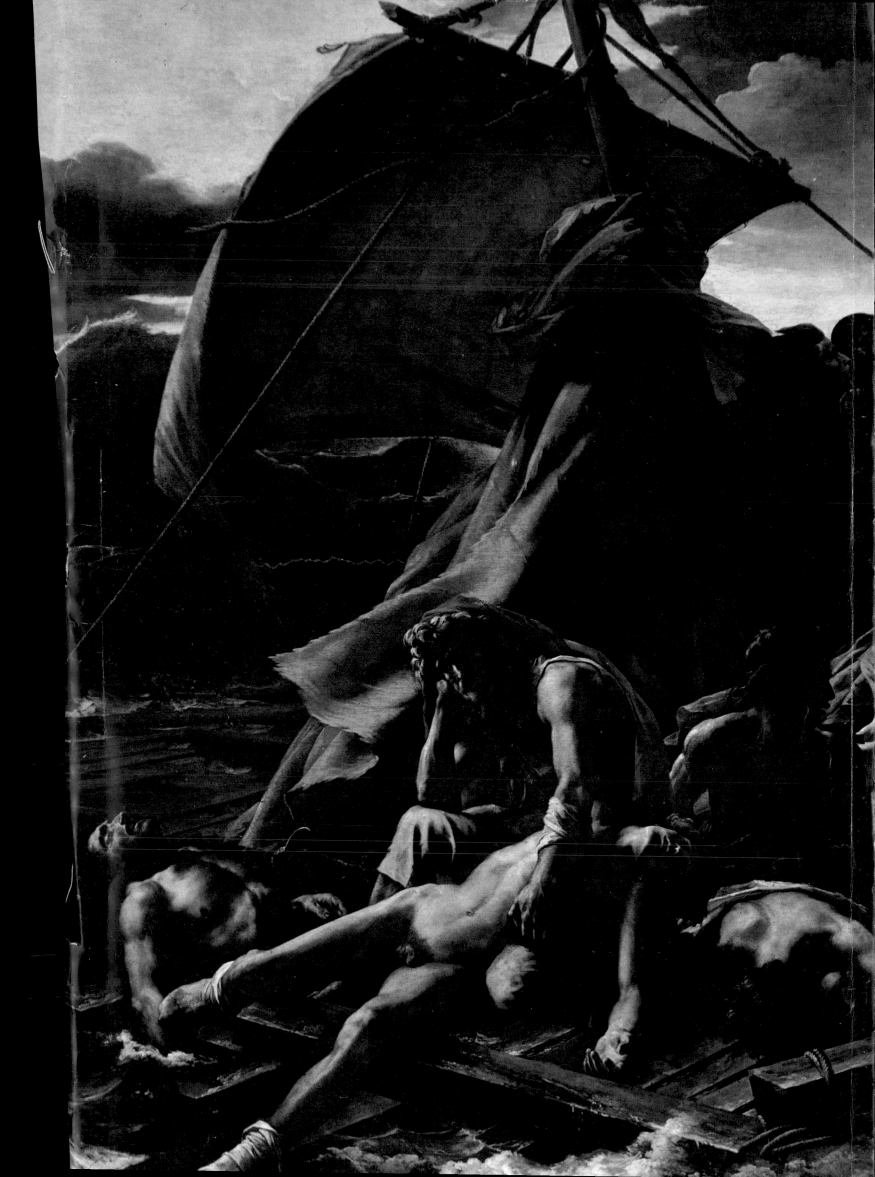

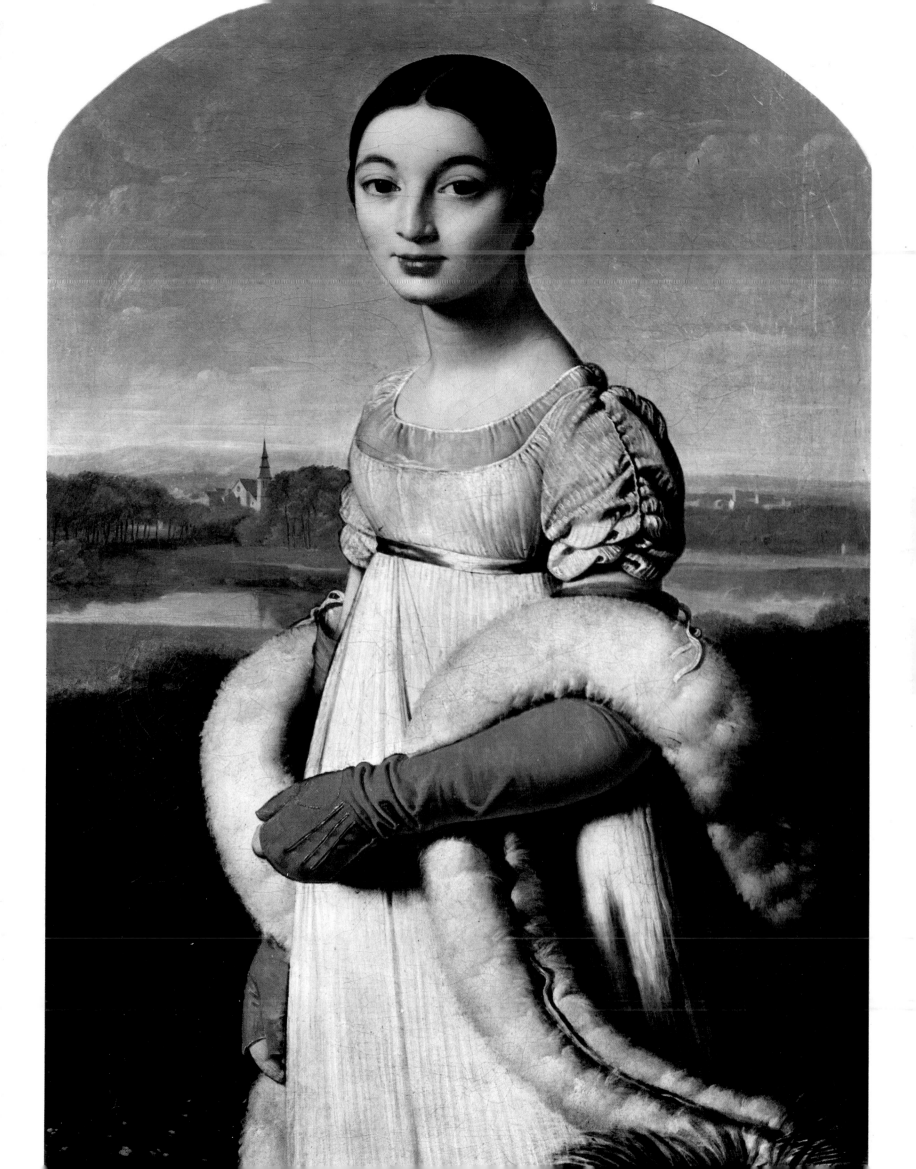

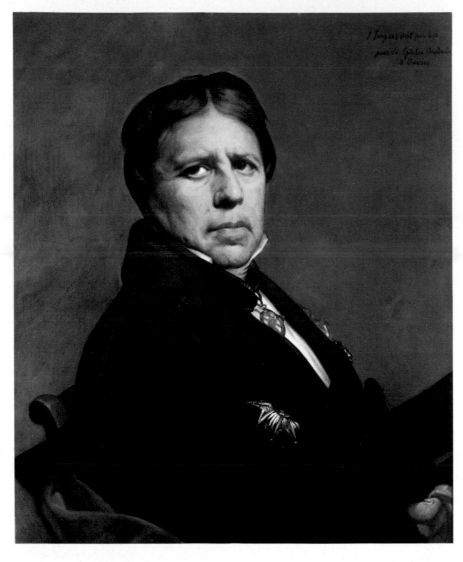

Ingres: *Self Portrait*, 64 × 53cm, 1864

one another but who combined observation and imagination with a minimum of reference to the past. Géricault and Corot represent opposing extremes. Corot seems to have been a relatively simple soul and followed the usual practice of going to Italy. But instead of making calculated quotations from Michelangelo he chose to observe the landscape around

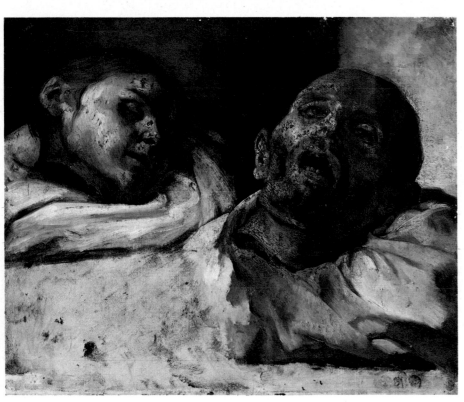

Gericault: *Heads of Executed Men*, 50 × 61cm, c.1820

him with a special feeling for the quality of the light. His compositions tended to be simple, almost artless by comparison to the conventions of the day. On his return to France he continued to call, for a time, on his unerring ability to record. He painted a few portraits as well, using the same technique. It was only in middle age (beyond the period covered by this book) that he evolved his generally poetic landscape in which all the edges became slightly blurred. Thus in old age, though respected, Corot became the symbol of a backward-looking art, quite the opposite of the way he had started out.

By contrast Géricault was impetuous, inconsistent and passionate. The term Romantic, which is usually associated with this type of painter, can then be neatly contrasted with the Classical style of Ingres. Often such categories serve to confuse rather than clarify. Géricault was far from being romantic when he painted his greatest picture, the *Raft of the Medusa*. It was a protest against the incompetence of the naval authorities at the time of a shipwreck. Géricault had several morbid obsessions. His restless energies concentrated on dismembered limbs, severed heads and scenes of execution. Yet critics persist in calling this Romantic. The same term is also applied to Delacroix even though from a stylist point of view almost the whole of Delacroix's art consists of erudite quotations from the Old Masters. But if Delacroix lacked ability to evolve a personal style of painting he made up for it in his power of imagination. He could be inspired by the unashamedly Romantic poetry of Byron or the historical

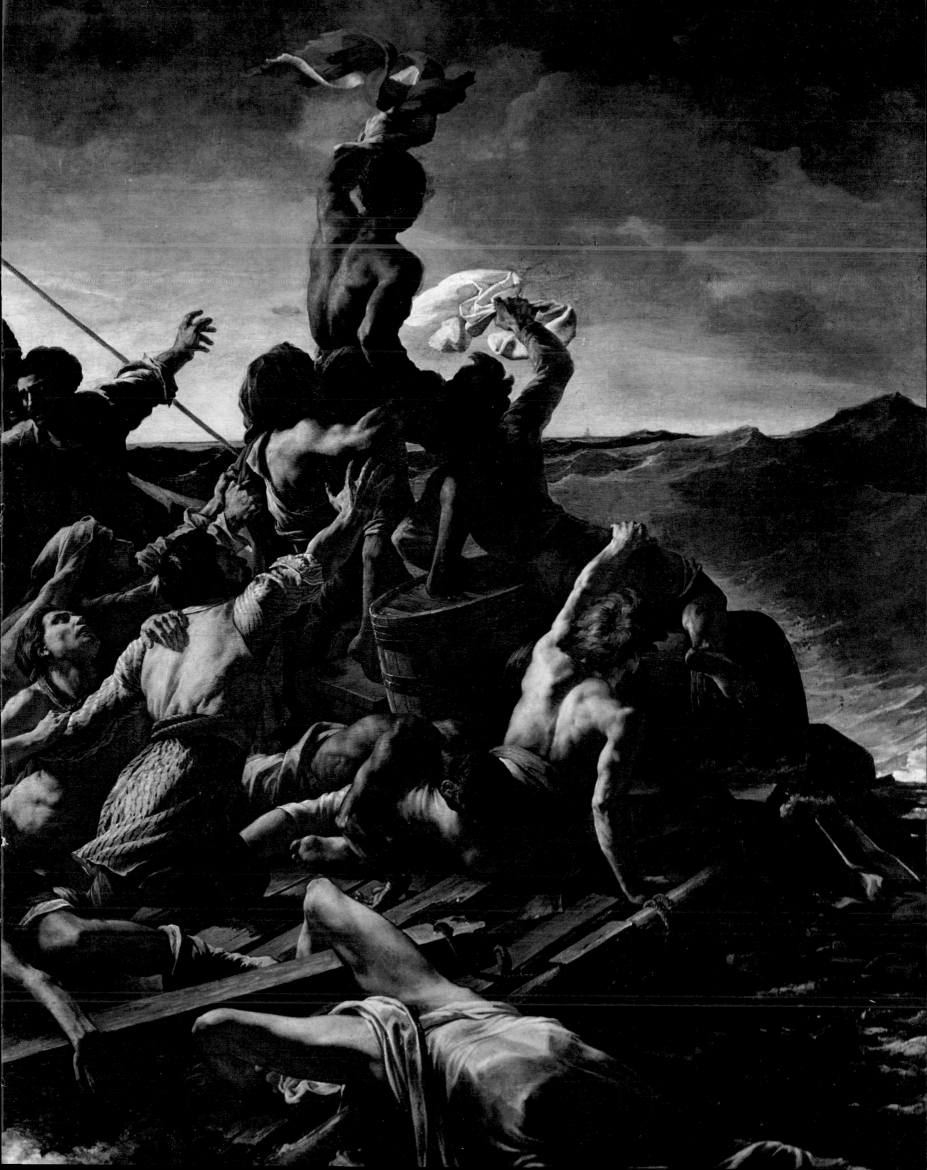

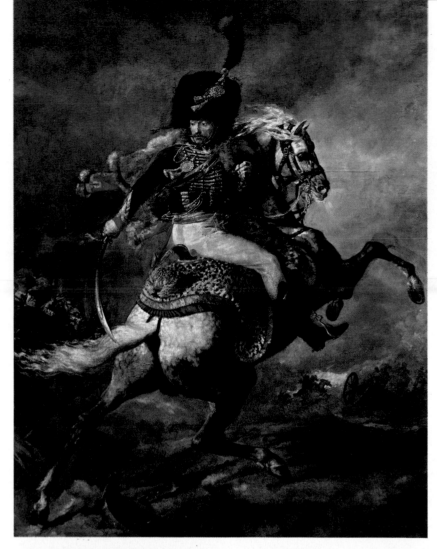

novels of Sir Walter Scott, and he then translated them into
visual terms. He was able to see vividly in his mind the
Murder of the Bishop of Liège or Byron's *Giaour*, but his hand
lacked the sensibility of his brilliant mind.

The first half of the nineteenth century in France was a
period of paradoxes. The restored Bourbons gave way in
1830 to the relatively liberal regime of Louis-Philippe. In

Gericault: *The Derby at Epsom*, 88 × 120cm, 1821

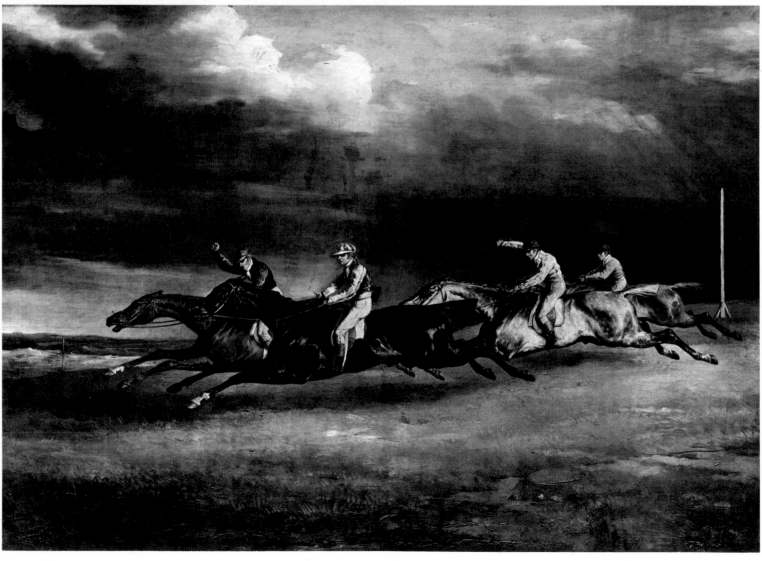

contrast to artists of earlier periods painters were free to produce almost anything they pleased. This freedom produced a new series of standards which soon became frozen into conventions. The once avant-garde Ingres became, as he continued to paint his nudes and portraits, a symbol of academic respectability. Ingres is studied for his stylistic innovations, for his bringing up to date of David's style in the early part of the century. But it is too easily forgotten that his style continued, almost unchanged, through a whole series of different stylistic periods. Constable's *Hay Wain* was exhibited at the Salon of 1824 and provoked Delacroix to repaint part of his *Massacre of Chios* in the light of what he had seen. Ingres painted through the first half of the century, changing his style but little, and acting as a kind of foil to the broad decorative schemes of Delacroix. It could be argued that the real end of the old order comes in the middle years

of the nineteenth century – precisely with the Revolution of 1848, which brought down the monarchy of Louis-Philippe. Academic painting continued almost until the end of the century, basing itself on lessons learned from Ingres rather than Delacroix. But once Gustave Courbet had achieved notoriety, and then success, the whole system, which gave painting a set of recognizable values, built up over the centuries and embraced by both Ingres and Delacroix, was to disappear for ever.

An important fact in the history of art, so often ignored, is the role played by the collector. Artists received patronage for important decorative cycles, such as Primaticcio's work at Fontainebleau and Le Brun's extensive activity first at Vaux-le-Vicomte and then at the Louvre and Versailles. Easel paintings from the seventeenth century onwards were often bought by the collector on the open market rather than

Delacroix: *The Women of Algiers.* 180 × 229cm, 1834

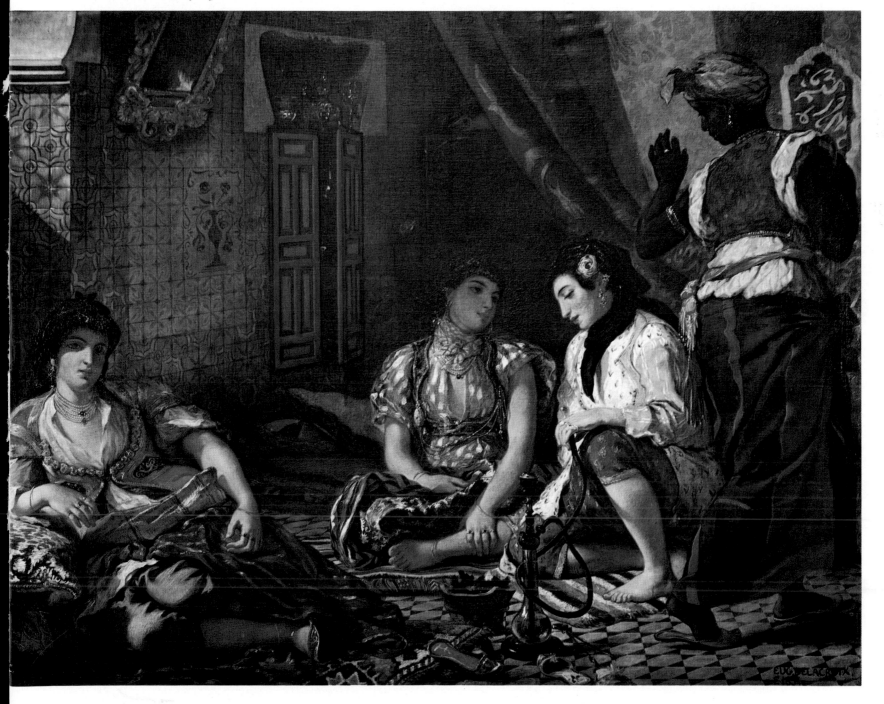

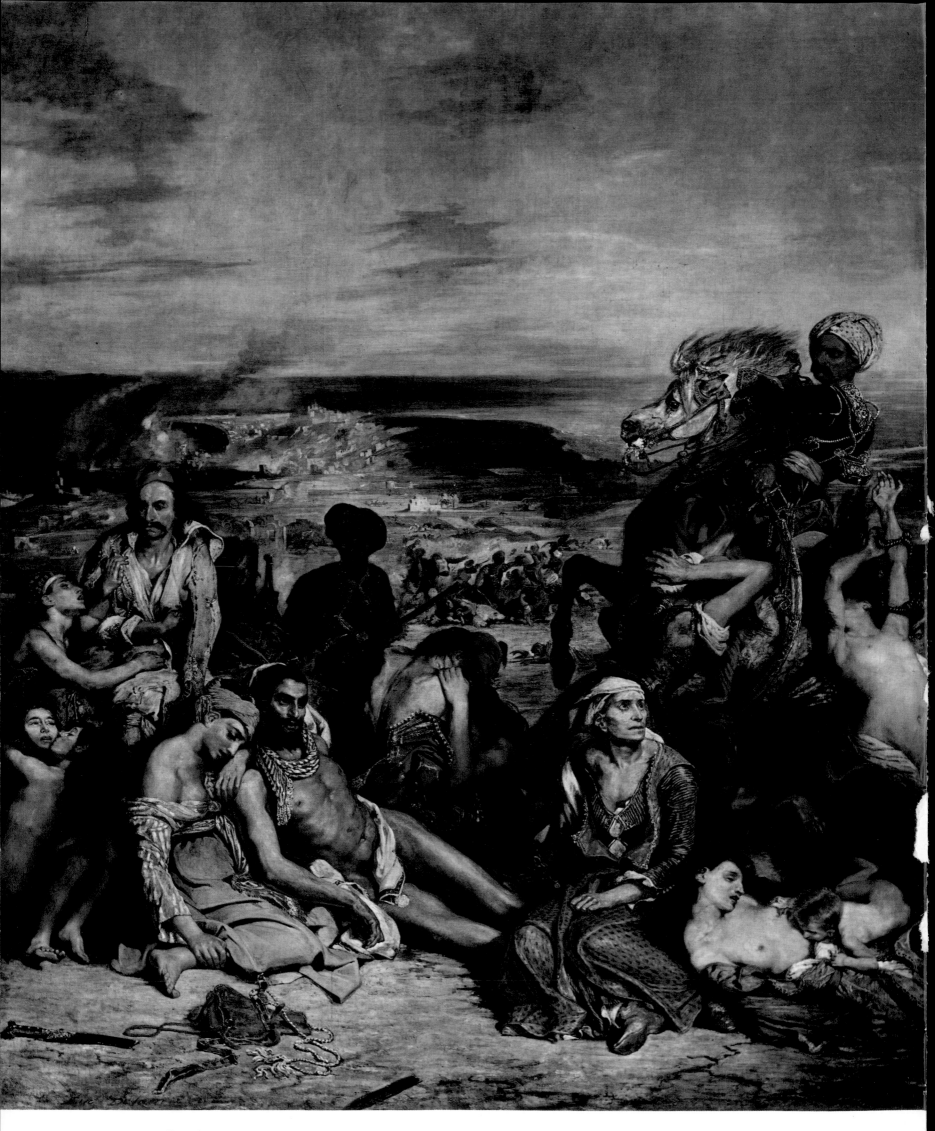

Delacroix: *The Massacre of Chios*, 417 × 354cm, and detail, 1824

The Greek War of Independence caught the imagination of many poets and painters, the most famous being Lord Byron, who died in Greece. Delacroix chose to paint this tragic incident and gave it a genuinely Romantic grandeur — a characteristic which incidents of this type when recorded by modern photography certainly do not possess. The real squalor of the scene is totally ignored in order to produce a broad canvas of naked figures set against a broad landscape. It is difficult to tell to what extent Delacroix changed the picture in a hurry after seeing Constable's *Hay Wain*, when it was exhibited at the Paris Salon in 1824.

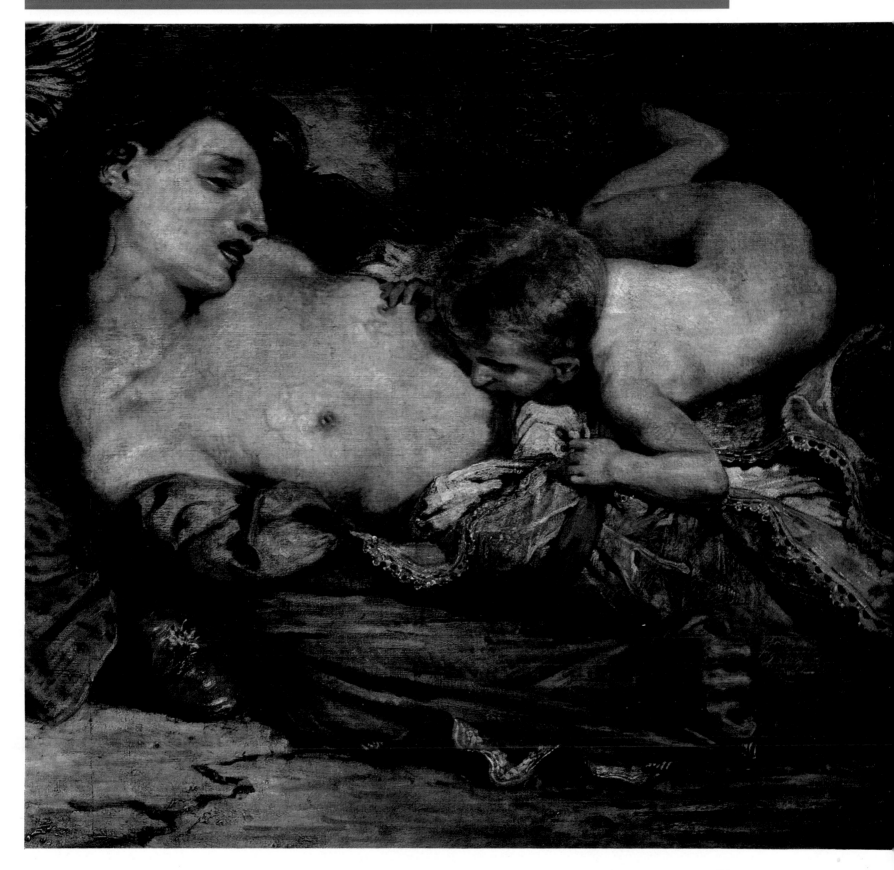

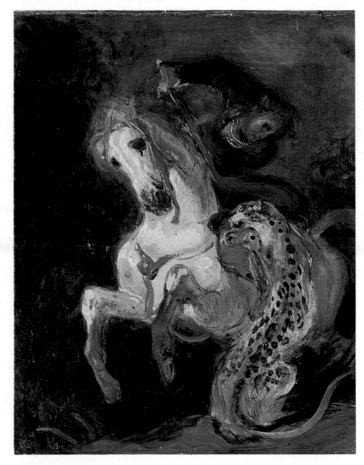

directly from the artists. Poussin is an exception as he did not produce pictures to be sold on the open market. His slow working methods meant that his pictures went straight to the individual patrons eagerly awaiting their completion.

The turbulent political history of France from the Revolution onwards has had interesting effects on the pattern of collecting and thus on taste. After 1789 the whole of eighteenth-century painting was immediately despised for

ABOVE LEFT **Delacroix:** *Apollo,* 130 × 97·5cm, c.1850

ABOVE **Delacroix:** *Horseman Attacked by a Jaguar,* 28·5 × 23·5cm, 1850

LEFT **Delacroix:** *Liberty at the Barricades,* 260 × 325cm, 1830

Delacroix: *The Death of Sardanaplus*, 395 × 495cm, and details (RIGHT and PAGES 74–5), 1827

political reasons. The art of earlier centuries was either forgotten or was masquerading in collections under Dutch or Italian attributions. Such was the oblivion of late medieval French painting that it was not until 1904 that an exhibition was held in Paris bringing together all the then known surviving work. After this period of neglect of native painting, the middle years of the nineteenth century saw a revival of interest quite unprecedented in any other European country.

A brilliant generation of French writers rediscovered many different aspects of the art of the previous two centuries. The indefatigable Champfleury searched the archives of Laon and rediscovered the Le Nain brothers. The brothers Goncourt covered the whole eighteenth century in a way which was at once sentimental and perceptive. They brought to life for the first time for nearly a century the all but forgotten world of the eighteenth-century court. They wrote about the pastel portraits of Maurice Quentin de La Tour;

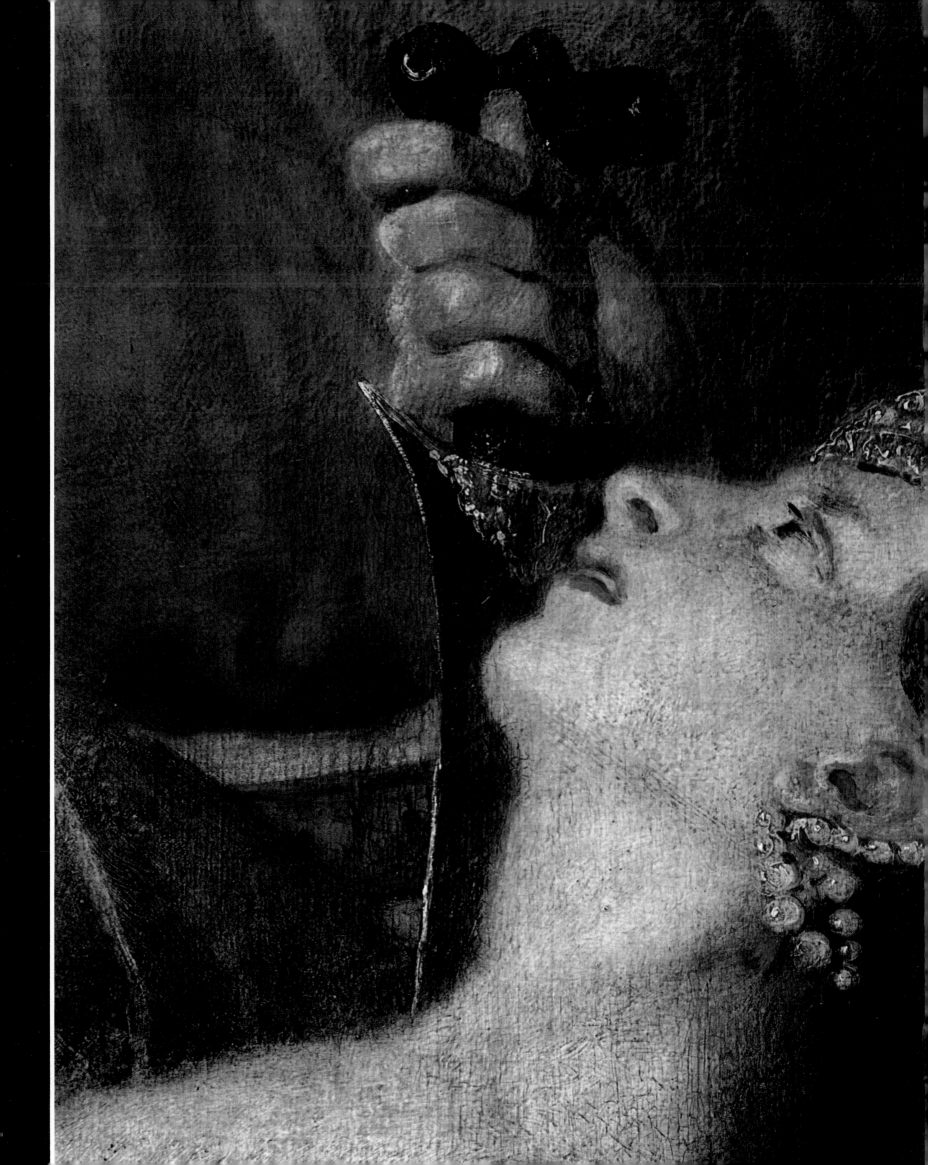

Above **Corot:** *View of Avignon*, 34 × 73cm, c.1836

Corot is known to have been in Avignon in the summer of 1836, and it is likely that this picture dates from that year. In his youth in Rome he had already begun to paint pictures with an open air feeling, and *View of Avignon* captures perfectly the atmosphere of clear warm light so often seen in the South of France. The distant town on the horizon is recognizable as Avignon, especially because of the silhouette of the Palace of the Popes. Many writers have interpreted Corot's pictures of this type as the forerunners of Impressionism. Corot had no elaborate colour theories, as the Impressionists were to evolve. Instead he was concerned with recording the landscape with complete tonal accuracy.

LEFT **Corot:** *Woman with Marguerites*, 78 × 58cm, c.1870

they made Fragonard fashionable again, and had a profound appreciation of Watteau, who until the La Caze bequest of 1869 was hardly represented in the Louvre at all. Thus French eighteenth century only became appreciated again in the late nineteenth century. The twentieth century has added relatively little with the exception of Georges de La Tour. Several provincial painters of the seventeenth and eighteenth centuries, most of them rather minor, have been rehabilitated in the form of comprehensive exhibitions in their towns or regions of origin. It has therefore become relatively easy to study the course of painting in the provincial centres since so much work has now been done on Lorraine and the South.

By curious paradox, the study of the mainstream of French painting is more difficult. Many major artists are relatively unexplored. Experts cannot agree on the canon of Watteau's limited output. The interpretation of Poussin is still a matter for discussion, and many pictures hang inscrutably on the walls of the Louvre, resisting the efforts of

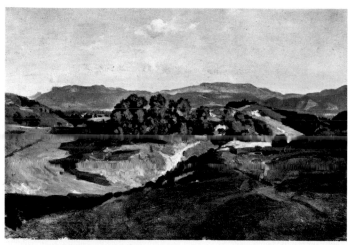

Corot: *Olevano*, 33·5 × 47cm, 1827

scholars to identify them; even where the artist is known, their significance in the individual's career is often uncertain.

It is unlikely that the general pattern of French painting down to Delacroix will be subject to radical reappraisal by major discoveries. The academic painters are now in the process of being rehabilitated, but even their most fervent apologists still regard most highly the delicacy of Watteau or the humility of Chardin. Unfortunately there is no grand equivalent of the *Sistine Chapel* or the *Night Watch* in French art. Mme du Barry's Salon, now in the Frick Collection of New York, has already been described as a brave attempt. But the moments of experience of the true greatness of French art often occur in front of small pictures in unexpected places. The eighty odd pastel portraits by Maurice Quentin de La Tour at St-Quentin still have the impact today

Corot: *The Forest of Fontainebleau*, 52 × 55cm, c.1828

French Painting: **Corot**

Below Corot: *Woman in Blue*, 80 × 50cm, 1874

Although Corot was primarily a landscape painter he occasionally tried other subjects, including both still life and figure painting. In his early years he favoured small, intimate portraits, but later concentrated on larger figure studies. These are usually of women, often dressed in a smoky-blue costume. They often stand aloof, lost in thought, seemingly quite unaware of being painted. In this late picture Corot seems to have taken no notice of the development of painting brought about by Courbet in the 1850s and Manet in the 1860s.

Corot: *Gipsy with a Mandolin*, 80 × 57cm, 1874

which moved the Goncourt brothers more than a hundred years ago. They reveal perfectly a way of life quite unsympathetic to our own. Watteau's *Embarkation for Cythera* on one level is a scene of impossible people in an impossible world. But this is to miss the point. So many of the best French painters can produce a feeling of escape.

Poussin's artificial antiquity, Watteau's parks, Fragonard's unending sense of fun, all these deny the real world. By contrast there are those painters who struggled to record the world as they saw it. Georges de La Tour's obsession with candlelight produces, at his best, pictures that inspire the imagination. The Le Nain brothers' peasants rise above their daily existences, which makes them so different from their Dutch counterparts.

In the final analysis the most potent enemies of the appreciation of French art have been those who have sought to apply the standards learned in the appreciation of Dutch and Italian art. Unfortunately most connoisseurship is based on an admiration of one or other of these schools, but rarely both. There is some Italian or Dutch influence to be found in most French art before the middle of the nineteenth century. However, the real qualities of so many French painters lie in their passionate individualism.

That they should be appreciated on their own merits is a plea that should be reiterated.

OPPOSITE **Corot:** *Bouquet of Roses*, 32 × 24cm, 19th century

List of Illustrations

Bibliography

RING, GRETE: *A Century of French Painting*, 1948
BÉGUIN, SYLVIE: *L'Ecole de Fontainebleau*, 1960
BLUNT, ANTHONY: *Art and Architecture in France, 1500–1700*, 1970
LEVEY, MICHAEL and KALNEIN, W.: *Art and Architecture of the 18th Century in France*, 1972
GONCOURT, E. and J. DE: *French Eighteenth Century Painting*, 1948
French Painting 1774–1830: The Age of Revolution, Detroit, Institute of Arts; New York, Metropolitan Museum of Art, 1975